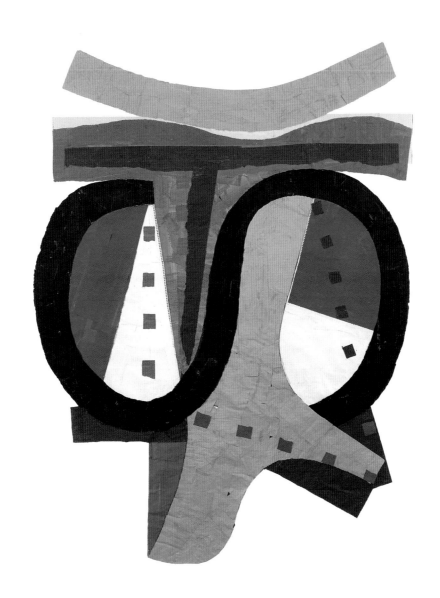

FRITZ BULTMAN:
COLLAGES

Curated by

Evan R. Firestone

With essays by

Evan R. Firestone
Donald Windham

Georgia Museum of Art, University of Georgia

Cover: *Mardi Gras,* 1978
 Pasted paper and gouache
 96 ½ x 48 ½ inches
 Hunter College, City University of New York

Frontispiece: *In the Wave,* 1973
 Pasted paper and gouache
 64 x 48 inches
 Collection of Lola and Allen Goldring,
 Woodbury, New York

© 1997 Georgia Museum of Art, University of Georgia

"Fritz: Sketches" © 1997 Donald Windham

"Between Sculpture and Painting" © 1997 Georgia Museum of
Art and Evan R. Firestone

Published by the Georgia Museum of Art, University of Georgia.
All rights reserved. No part of this book may be reproduced
without the written consent of the publishers.

Design: Ron Evans and Barry Stock (Kudzu Graphics)

Body Copy: PMN Caecilia Roman

Department of Publications: Bonnie Ramsey, Jennifer
DePrima, and Rose Pezzuti

Printed in an edition of 1,500 by Friesens

Printed in Canada

Generous support for this exhibition and catalogue has been
provided through a grant from The Judith Rothschild
Foundation. Partial support for the exhibitions and programs at
the Georgia Museum of Art is provided by the Georgia Council
for the Arts through appropriations of the Georgia General
Assembly and the National Endowment for the Arts. A portion
of the museum's general operating support for this fiscal year
has been provided through the Institute of Museum and Library
Services, a federal agency that offers general operating support
to the nation's museums. Individuals, foundations, and corpora-
tions provide additional support through their gifts to the
University of Georgia Foundation.

Library of Congress Cataloging-in-Publication Data

Bultman, Fritz, 1919-1985.

Fritz Bultman : collages / curated by Evan R. Firestone;
with essays by Evan R. Firestone, Donald Windham.

 p. cm.

Catalogue of exhibition held at the Georgia Museum of Art,
University of Georgia, Nov. 1, 1997-Jan. 18, 1998.

 Includes bibliographical references.

 ISBN 0-915977-33-8

 1. Bultman, Fritz, 1919-1985—Exhibitions. 2. New York
School of Art—Exhibitions. I. Firestone, Evan R.
II. Windham, Donald. III. Georgia Museum of Art. IV. Title.

N6537.B847A4 1997 97-14814
709.2—dc21 CIP

TABLE OF CONTENTS

This exhibition and catalogue are
made possible through a grant from

The Judith Rothschild Foundation

LENDERS TO THE EXHIBITION

BOWDOIN COLLEGE MUSEUM OF ART
Brunswick, Maine

ANTHONY BULTMAN
New Orleans, Louisiana

JOHANN BULTMAN
New Orleans, Louisiana

MR. AND MRS. WILLIAM FRANKEL
Philadelphia, Pennsylvania

ABBY AND B. H. FRIEDMAN
New York, New York

TIMOTHY FOLEY, TILDEN-FOLEY GALLERY
New Orleans, Louisiana

LOLA AND ALLEN GOLDRING
Woodbury, New York

HUNTER COLLEGE,
CITY UNIVERSITY OF NEW YORK
New York, New York

MR. AND MRS. GEORGE P. KRAMER
New York, New York

MONTCLAIR ART MUSEUM
Montclair, New Jersey

NATIONAL MUSEUM OF AMERICAN ART,
SMITHSONIAN INSTITUTION
Washington, D.C.

ROGER HOUSTON OGDEN
New Orleans, Louisiana

VERA AND STEPHEN L. SCHLESINGER
New York, New York

GALLERY SCHLESINGER
New York, New York

DONALD WINDHAM
New York, New York

TULANE UNIVERSITY
New Orleans, Louisiana

JOHN AND KATE TURBYFILL
Virginia Beach, Virginia

THE ESTATE OF THE ARTIST

ACKNOWLEDGEMENTS

In 1976, drawn by a name I vaguely knew, I went to the Martha Jackson Gallery on Manhattan's East Side to see an exhibition of Fritz Bultman's sculpture and collages. I was rewarded with an impressive show. A year later I had the opportunity to meet the artist, and we stayed in contact until his death in 1985. The many hours Fritz generously spent with me discussing his work led to the publication of a short essay in *Arts Magazine* in 1981 and provided the foundation for my later research.

Following the Bultman retrospective that opened at the New Orleans Museum of Art in August 1993, I decided more could be done on the artist. April Kingsley's contributions to the exhibition catalogue and her other writings on Bultman were very informative, but I had become aware of a substantial amount of archival material in New York and Washington, D.C., that had not been previously utilized. My visits to the Archives of American Art in Washington, D.C., were very productive, thanks to the assistance of Judy Throm.

William U. Eiland, director of the Georgia Museum of Art, and the museum's exhibition committee responded enthusiastically to my proposal to do a Bultman collage exhibition, which provided the incentive to pursue the topic. I am particularly indebted to Donald Keyes, curator of paintings, for his encouragement and work on behalf of the project. Lynne Perdue, registrar for the museum, was the model of efficiency in securing the loans for the exhibition. Bonnie Ramsey, director of publications, and Jennifer DePrima, her editorial assistant, once again demonstrated the museum's ability to produce carefully edited and handsome publications. Betty Alice Fowler's preparation of the proposal to The Judith Rothschild Foundation resulted in funding that enabled production of this substantial and beautifully illustrated catalogue.

The Georgia Museum of Art and I are very grateful for the funding provided by The Judith Rothschild Foundation. The foundation's commitment to the re-examination of important yet under-recognized artists considerably expands our conceptions of American art.

Kristi Kohl, recommended to me by Donald Keyes, assisted with many details, including research on citations for the bibliography. Jane Sanders, administrative secretary in the Lamar Dodd School of Art, retained her patience and good nature as I incessantly tinkered with my essay.

It has been my pleasure to become acquainted with Donald Windham during the course of my research these last few years, and my honor to collaborate with him on the catalogue. Stephen Schlesinger, whose gallery in New York handles the artist's estate, also happily shared his knowledge of Bultman's work with me. Needless to say, this exhibition depends on the generosity of lenders, who are acknowledged separately.

This project would not have taken its present form—indeed, may not have been undertaken at all—without the cooperation and support of Jeanne Bultman, the artist's wife. She devoted countless hours, in her

home and by telephone, responding to my requests for information. She gave me free access to records, notebooks, letters, and other documents that had not been donated to the Archives of American Art, and she provided most of the photographic material used in this catalogue. Her unflagging energy and devotion are an inspiration.

EVAN R. FIRESTONE
CURATOR OF THE EXHIBITION
PROFESSOR OF ART HISTORY,
LAMAR DODD SCHOOL OF ART,
UNIVERSITY OF GEORGIA

ACKNOWLEDGEMENTS

This exhibition of Fritz Bultman's collages owes much to the extraordinary retrospective of his entire oeuvre in painting, collage, and sculpture shown at the New Orleans Museum of Art in 1993. It is true that such exhibitions validate the career of an artist, but the best ones do more: they propose new questions and urge other scholars and curators to re-examine and to re-investigate the work of an artist who has been neglected. Fritz Bultman's collages were included in the retrospective of 1993, but they remained enigmatic, powerful objects that deserved greater scrutiny. In this latter part of the twentieth century, museums are hesitant to mount monographic exhibitions for fear that they will be criticized for fostering or preserving the notion of genius in face of a pseudo-egalitarian contemporary criticism that favors trend over originality. Bultman's role in twentieth-century American art demands that we take a closer look precisely because his separation signaled difference: difference in temperament, in ability, and in development. The collages are a singular manifestation of his position among but outside the group known as the New York School.

Collector Jordan Massee remembers the day in the early 1940s when he met Fritz Bultman for the first time. Massee lived in a fifth-floor walk-up in Manhattan, and his first memory of Bultman was when he arrived one day with Tennesee Williams, who introduced him as "Little Fritzie." Massee recalls that Bultman was delivering what he claimed to be a portrait of Williams, but "it was so abstract that it could have been a portrait, a mountain, a church, anything at all." Massee remembers further that Bultman was "very young, very clever, and very amusing." The collages in this exhibition bear witness to Massee's early observations: Fritz Bultman was a clever, even daring artist, one who literally pushed composition to the edge in order to resolve problems of space and surface. Bultman's collages are visual records of a belief recorded in his notebooks that "whatever is burning, inescapably real and important; whatever is the inevitable choice; whatever has to get onto the canvas, despite will, knowledge, taste and a hundred other obstacles...," is the artistic reality toward which he strived.

We are grateful for the chance to share with our audiences, through this exhibition and catalogue, Bultman's vision of the "inescapably real and important." We are fortunate to have Evan Firestone as the curator of the exhibition; his painstaking care and informed decisions have meant that we have had the liberty to make plans well in advance, a luxury the staff and I are not generally allowed. We also thank Donald Windham for his essay, which joins Professor Firestone's in giving us a more complete and more intimate look at Bultman and his art. We also join our curator in acknowledging with appreciation the assistance of Mrs. Jeanne Bultman.

Without the generosity of our lenders, the exhibition would not have been possible, and we express sincere gratitude to them. The Judith

Rothschild Foundation's financial support came at the most opportune time in the development of the exhibition, and we are thankful to its board for their belief in the project and for helping us to make this catalogue a more complete record.

The staff of the Georgia Museum of Art deserve acknowledgement for their careful attention to this and our other exhibitions and catalogues. In particular, I thank Bonnie Ramsey and Jennifer DePrima for guiding this publication through to completion; Jim StipeMaas, Greg Benson, and Lanora Pierce for designing and installing the exhibition; Donald Keyes, Lynne Perdue, and Annelies Mondi for assisting our guest curator in arranging for the loan and shipment of the objects; and Betty Alice Fowler for proving once again her mettle under the fire of deadlines.

WILLIAM U. EILAND
DIRECTOR, GEORGIA MUSEUM OF ART

BETWEEN SCULPTURE AND PAINTING

WHY A FRITZ BULTMAN COLLAGE EXHIBITION?

At the beginning of Fritz Bultman's sustained period as a maker of collages, Pop Art and Minimalism were staking their claims in the art world. Had Bultman shown his modest-sized collages in the 1960s, with their characteristic abstract-expressionist features, they may have been regarded as belated entries in the ongoing development of American modernism, particularly as few observers would have associated them with a pioneer of the New York School. A decade later Bultman's collages, periodically exhibited at the Martha Jackson Gallery in New York, displayed a surprising synthesis of European modernism and Abstract Expressionism. The critic Douglas Crimp found the collages "reminiscent of late Matisse in their monumental size (some are eight feet high), sensuous shapes and exuberant red, blue and gold acrylic colors," and he noted that "these works vie with the heroicism of New York School painting and sculpture."[1] Although the collages utilize gouache rather than acrylic pigments, Crimp's analysis would be reiterated by other critics, including April Kingsley, who wrote, "in their joyous celebratory expansiveness [the collages] recall late Matisse papier[s] collés … [but] they are also typically Abex in their gestural, unselfconsciously energetic impact…."[2]

Despite occasional positive notices, including critic Hilton Kramer's declaration that the collages "are almost prodigal in their brilliance,"[3] they remained the pleasure of a relatively small circle of admirers, many of whom were artists. Bultman's friend Robert Motherwell, himself renowned for collage, freely acknowledged his appreciation of Bultman's collages as well as his work in other media. In 1988, three years after Bultman's death, Motherwell wrote:

> After forty years of acquaintanceship with Fritz Bultman and his work, I am
>
> still convinced that he is one of the most splendid, radiant and inspired
>
> painters of my generation, and of them all, the one drastically and shock-
>
> ingly underrated…. [W]hatever the reason for the neglect of his work, I still
>
> find it as radiant as ever, after all these years. I even have a color repro-
>
> duction of one of his works hanging in the tiny Pantheon of other works
>
> that I admire, in reproduction, pinned to the wall of my studio.[4]

Motherwell's appreciation extended beyond a reproduction pinned to his studio wall; in 1978 Bultman noted in a journal that Motherwell had bought two of his collages.[5]

The high regard of Motherwell and others might seem reason enough to take another look at Bultman's collages. Their sheer beauty—"radiant" for Motherwell, "prodigal in their brilliance," according to Kramer—justi-

fies a substantial exhibition. In addition, Bultman's elaboration on Matisse's cut-paper technique should be understood as an important contribution to the history of twentieth-century collage. In 1993 the New Orleans Museum of Art mounted a large retrospective of Bultman's work that included twenty-six collages, but neither the exhibition nor its catalogue systematically explored their formal development and possible meanings.[6] This is the purpose here.

Some discussion of terminology is in order. Bultman referred to his work with paper and paint as collage, as have all who have written about it. As William Rubin of the Museum of Modern Art has noted, the terms *collage* and *papier collé* have too readily been used interchangeably, a casual practice of which he disapproves. According to Rubin, collage is characterized by "the anti-classical principle of the *mélange des genres*," whereas *papier collé* is "governed by the classical principle of the unity of medium."[7] By these definitions, Bultman's works are *papiers collés*. Although Rubin's distinction is well taken, we will continue to use the term collage in keeping with Bultman's designation and so as not to create a new label for his work.

BULTMAN'S SYNTHESIS

Bultman had made a few collages over the years beginning in the late 1930s, but his purposeful investigation of collage began in 1962. His records indicate he created about sixteen that year.[8] He continued to make collages, which became his major preoccupation until his death twenty-three years later. By the early 1970s Bultman had begun to realize the potential of his evolving method. Exhibitions at the Martha Jackson Gallery in 1974 and 1976 gave full evidence of his new approach to collage and marked the approximate midpoint in his exploration.

In the Wave [Plate 11], shown in the 1974 exhibition, is a representative work of this period. Bultman began by painting entire drawing pads with the unmixed gouache colors he favored: the primaries, ochres and siennas, and black and white. Then, cutting and tearing, Bultman pieced countless sections of paper together, temporarily holding them in place with push pins on his studio wall. When he was satisfied with various shapes, he secured them with Elmer's Glue. As Bultman wrote:

> I took the painting of papers with gouache from Matisse's cut-outs, but I
>
> began to work anew in collage from a center outward, rather than working
>
> on the confines of a sheet of paper. By adding piece to piece I find a
>
> means to give me a collage of random shape through random growth....[9]

The finished work, unrestrained by the rectilinear edges of the support, was free to assume any shape dictated by the internal development of the composition. These collages may have been unpremeditated, but they yielded Bultman's characteristic form language: looping curves, straight and undulating bands of color, irregular geometric shapes, and almost always tracks of small, uneven squares at more or less regular intervals.

Bultman's use of saturated color, his love of the arabesque, and his disposition for repeated patterns on a large scale can be reminiscent of Henri Matisse. Matisse, however, conceived of his cutouts as "signs" on a

background. This is evident in the maquettes he made for *Jazz* during World War II and in the great *découpages* of 1952-53. Bultman's accretive method of "random growth," on the other hand, produced compositions of interlocking colored shapes that tend to limit figure-ground relationships within the constructions. Also, unlike Matisse, he made adjustments by applying successive layers of paper, causing the work to become thick in places. Bultman had discovered a way to re-employ Matisse's cut-paper technique by utilizing an abstract-expressionist approach to composition. His collages may suggest a relationship to the shaped canvases of the 1960s, but work in this idiom had to be planned in advance.

Although developed on the wall as independent structures, the problem was that the collages could not go unprotected. Bultman did not want to relinquish his fragile materials because only pure gouache colors and premium bond paper could give him the luminosity and transparency he desired. In the mid-1970s Bultman began working his collages directly onto large sections of canvas, which gave them greater support and allowed him to pursue random shapes by cutting away the excess canvas. Nevertheless, the gouache and paper surfaces remained vulnerable. Reluctantly, he had the collages mounted and framed behind Plexiglas.[10] This not only establishes figure-ground relationships with the backing material, but, additionally, the collages often appear uncomfortably confined. Bultman struggled with this problem for years, even having a shaped Plexiglas box made for one of his larger pieces, which also proved unsatisfactory. The collages Bultman made toward the end of his life conform to the rectangular frame, although he still hoped to find a solution. He told a journalist in 1981, "It's a technical problem: how to get these so they're totally random and can be hung on a wall with no reference to a rectangle. I know it's possible. I know that I'm going to get back into this."[11] Unfortunately, in that year Bultman was diagnosed with cancer, and his time was limited.

BIOGRAPHICAL BACKGROUND FOR THE COLLAGES

Fritz Bultman was born in 1919 into a prominent and cultured New Orleans family who owned The House of Bultman, a funeral home at St. Charles and Louisiana Avenues in the Garden District.[12] He was a sensitive, artistically inclined child who from an early age responded to color and design. As an adult he remembered a "marvelous cloisonné vase with a peony on it in blue and pink cloisonné that I love[d] more than anything...."[13] His direction toward art was confirmed in the summer of 1932 when the painter Morris Graves, then twenty-one, visited New Orleans and accepted the Bultman family's invitation to stay with them. As recounted to critic and art historian Irving Sandler in a 1968 interview, Graves and the thirteen-year-old Bultman spent a considerable amount of time together talking about art and sketching at Audubon Park.[14]

In the fall of 1935 Bultman departed for Munich, Germany, with a group of American high school students on a junior year abroad program, but he was dissatisfied with the educational and housing arrangements and left the program. Fortunately, he met Hans Hofmann's wife, Maria, known as Miz, who remained in Germany for a number of years after her husband emigrated to the United States. She took the adolescent

Bultman in as a boarder, and acted as a surrogate parent. He lived with her in 1936 and 1937 while attending a preparatory school, during which time he "became aware of the totally forbidden life of modern art."[15] His stay in Munich began a lifelong friendship with Mrs. Hofmann and subsequently with her husband.

Bultman returned to the United States in 1937 and enrolled in Chicago's New Bauhaus, which Laszlo Moholy-Nagy established that year. To appease his parents he went to Chicago under the pretense of studying architecture, but his intention was to study art. He found the experience a disappointment because, in his words, the school was "anti-painting."[16] It was there, however, in an environment that encouraged constructivist approaches, that Bultman made his first collages. In the summer of 1938 he headed east to study with Hans Hofmann, spending four years under Hofmann's tutelage in New York and Provincetown, Massachusetts, and becoming one of his favorite students.[17] Although Hofmann did little with collage, Bultman made several in the year or two after leaving Chicago. Those that survive are typically cubist in subject

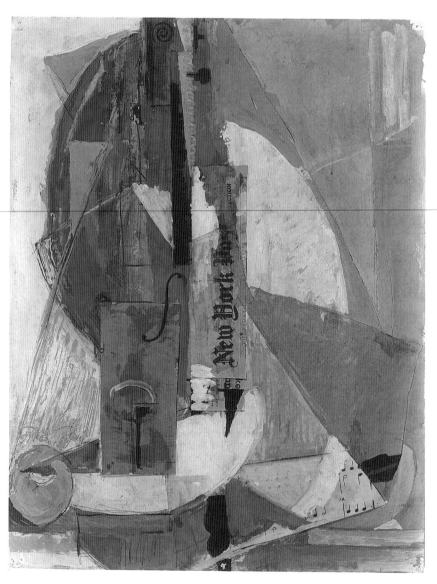

FIGURE 1 *New York Post,* 1939. Oil and paper on paper, 22 1/8 x 16 2/7 inches. Collection of Penny and Elton Yasuna.

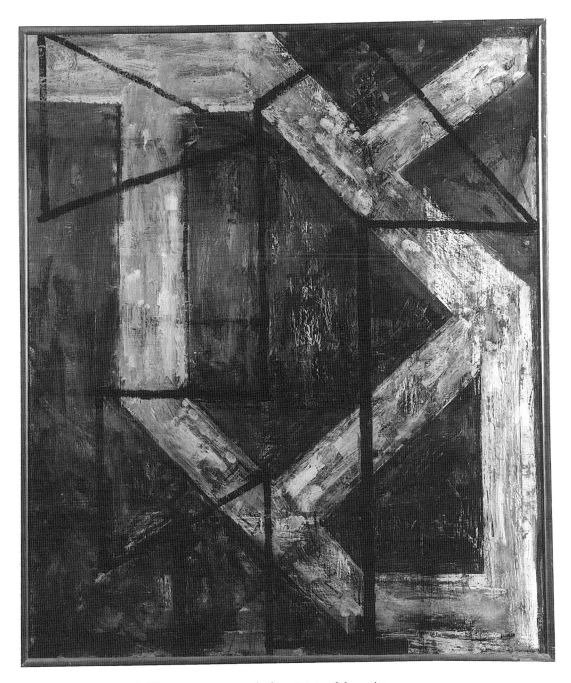

FIGURE 2 *Acteon*, 1946. Oil on canvas, 40 x 34 inches. Estate of the artist.

and structure (Fig.1). Basic features—the composition emanating from the center, the geometry of angular and curving shapes playing against each other, and sequences of marks—resurfaced in Bultman's later collages.

As Hofmann's student he came into contact with some of the most advanced art in the United States. He met Lee Krasner, another of Hofmann's students, almost immediately, and her future husband, Jackson Pollock, about 1940. During the 1940s his artistic and social relationships came to include many of the important figures identified with the development of Abstract Expressionism. While a painting such as *Acteon* (1946) retains the geometric structure of European modernism, its coarse appearance and reference to myth aligns it with tendencies associated with the origins of the New York School (Fig. 2). The reconciliation

of geometric abstraction and rough physical surfaces exemplifies Bultman's efforts to unite opposing elements throughout his career.

After exhibitions at New York's Hugo Gallery in 1947 and 1950 Bultman began an association with the Samuel Kootz Gallery, one of the important galleries identified with the early exhibition history of Abstract Expressionism. Kootz represented the painters Hofmann, William Baziotes, Adolph Gottlieb, and Robert Motherwell and sculptors Ibram Lassaw and David Hare. He invited Bultman to show a painting in his *Black or White* exhibition held in February and March 1950. Along with the gallery painters the exhibition featured works by American artists Willem de Kooning, Weldon Kees, Mark Tobey, Bradley Walker Tomlin, and the European artists Georges Braque, Jean Dubuffet, Joan Miró, Piet Mondrian, and Pablo Picasso. Kootz shrewdly promoted the American artists in this exhibition by presenting them with famous Europeans.

Two months after *Black or White* Bultman participated in an event that is legend in the history of the New York School. On Monday, May 22, 1950, the *New York Times* published a front-page article with the headline "18 Painters Boycott Metropolitan: Charge 'Hostility to Advanced Art.'" The article was in response to an open letter to the newspaper protesting the organization and memberships of the juries responsible for selecting the Metropolitan Museum of Art's competitive exhibition *American Art Today–1950*, to be held in December of that year. As controversy ensued over the following months, Bultman and his fellow artists became known as "The Irascibles." A photograph of the disaffected artists, published in the January 15, 1951 issue of *Life* magazine, constituted a virtual who's who of Abstract Expressionism, but Bultman was not in it. He missed the most important photo opportunity of his life because he had gone to Europe.[18]

It was Bultman's fortune, for good or ill, to be awarded a grant by the Institute of International Education to study technical aspects of sculpture in Italy. He departed New York in September 1950 and remained in Europe until June 1951 (the *Life* magazine photo shoot occurred in November 1950). After several fruitless months in Rome Bultman went to Florence, where he enrolled at the Istituto Statale d'Arte. The institute was basically a vocational school that emphasized materials and techniques, which is what he sought. At the institute he learned the techniques of bronze casting, which he later put to use in both unique lost-wax pieces and bronze editions.[19]

During his stay in Italy Bultman also traveled to France, which included a pilgrimage to Vence to see Matisse's work in the Chapel of the Rosary of the Dominican Nuns.[20] In 1953, two years after his return to New York, the Museum of Modern Art acquired Matisse's cut-paper maquettes for the front and back of his red chasuble, one of the vestment designs executed for the chapel. In the same year the museum also received the maquette for the *Nuit de Noël* window. These maquettes, made of paper painted with gouache, and Bultman's own copy of Matisse's *Jazz* portfolio, provided important models for his later work.[21]

The summer Bultman returned from Europe he formally joined the Kootz Gallery as one of its artists. A large painting called *Tides* was exhibited in September and sold to Nelson A. Rockefeller. Kootz, anxious for a solo exhibition as soon as possible, allowed Bultman to delay exhibiting

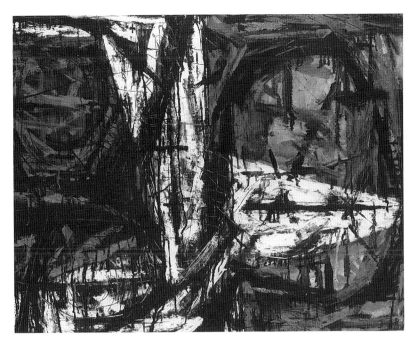

FIGURE 3 *Sleeper, Number 2, 1952.* Oil on canvas, 30 x 38 inches. Whitney
Museum of American Art, New York.

until September 1952 in order to give him time to create a body of new
work. He had not accomplished anything in Europe that could be shown.
At this point Bultman's psychological condition, always fragile at best,
began to disintegrate. He had suffered from bouts of depression and lassi-
tude for years, resulting in corresponding dry spells in his work. He was
tormented by a difficult relationship with his parents, especially his
father, upon whom he depended financially to support his life as an
artist, and he was in conflict about his sexual identity. He also hated to
meet dealers' deadlines.

In the late 1930s and early '40s, before his marriage to Jeanne Lawson
in 1943, Bultman had been associated with a gay literary-artistic circle
that moved between Provincetown and New York. During this time he
became preoccupied with the myth of Acteon, to which there is reference
in the titles of many of his works of the 1940s, reflecting his turbulent
state of mind. The hunter Acteon was transformed into a stag by Diana as
punishment for seeing her naked, whereupon he was torn to pieces by
his own hounds. Bultman's notebooks record yearnings for violent death,
the prospect of punishment for sexual transgression, and the agony that
accompanies the artist-seer as he tries to fulfill his vision. Along with his
other problems, the pressure of a one-man exhibition induced a panic in
Bultman arising from fears of failure and competition with his older and
better-known colleagues at the Kootz Gallery.[22]

The Bultmans had lived year-round in Provincetown since 1945, but in
March 1952, six months before the scheduled exhibition, they moved to
Manhattan where Fritz could receive psychiatric help. From May 1952
until November 1956 he was in analysis five days a week with Dr. Daniel
Shapiro. If it is possible to sense an artist's state of mind in abstract
imagery, the works Bultman produced leading up to the exhibition are

prime candidates for such interpretation. *Sleeper, Number 2* (Fig. 3), for example, is a dark, tangled composition that strongly suggests turmoil and violence. After the exhibition, which received modest coverage, Bultman's production drastically declined, and he dropped from sight. Over the next four years he invested virtually all his emotional energy in his therapy. At its conclusion he was able to resume work with renewed energy and a strategy for coping with creative blocks. He would work simultaneously in several media, which in time regularly included collage. Bultman's surge of energy resulted in a rapid succession of solo

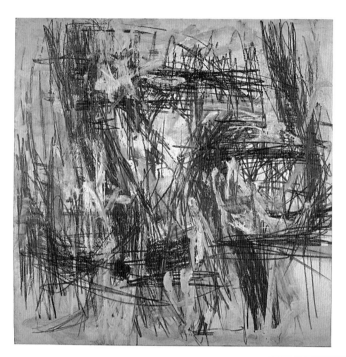

FIGURE 4 *Claretta I,* 1957. Oil, gesso, and pencil on board,
 22 x 22 inches. Estate of the artist.

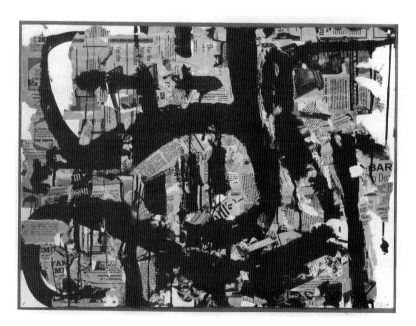

FIGURE 5 *Collage Number One,* 1957. Oil, gesso, and newspaper on board, 22
 x 30 inches. Estate of the artist.

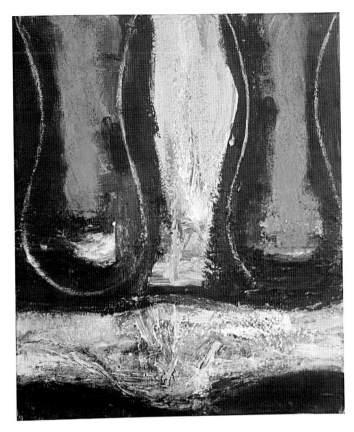

FIGURE 6 *M over W,* 1961. Oil on canvas, 24 x 20 inches. Estate
of the artist.

exhibitions in New York at the Stable Gallery in 1958, the Martha Jackson
Gallery in 1959, and Gallery Mayer in 1960.

RELATIONSHIP OF COLLAGE TO OTHER MEDIA

The collages stemmed most directly from Bultman's drawings and
sculptures, but they also are closely related to his paintings. He had been
making sculptures since 1951, and although he had always drawn, he
began working from the nude model on a regular basis in 1957. Drawing
was a purely pleasurable activity, a casual endeavor that did not carry the
burden of making works of art. He later referred to the daily sessions
with his model as "piano exercises," which prepared him for his other
work.[23] For three years he drew from Claretta, a black dancer (Fig. 4). With
their dense clusters of gestural markings, smudges, and effacements,
these drawings correspond to Bultman's paintings of the period. Three
surviving newspaper collages from 1957-58 link his abstract figure draw-
ings with a return to collage (Fig. 5). Broad contours in both the drawings
and the collages, made by repeated pencil markings or loaded brush, sug-
gest the volumes of the figure.

By 1961, in very large paintings as well as small, the imperatives of
draughtsmanship can be seen in the sinuous line that threads its way
through dense, uneven paint surfaces (Fig. 6). This same undulating line,
along with other graphic marks, appears in a new series of collages made
with torn pieces of drawing paper painted with gouache [Plates 1 and 2].
The connection to drawing is underscored by the remnants of the draw-
ing pad evident in the binder holes that leave their own distinctive tracks.
As the drawings became more precise and representational in the 1960s,

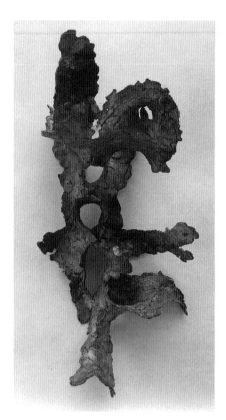

FIGURE 7 *Sea-Wrack,* 1959. Bronze,
17 x 8 x 3 inches.
Collection of Mr. and Mrs.
Harry Tobey.

the collages and paintings, while remaining resolutely abstract, shed their obvious ties to Abstract Expressionism.

Bultman noted on several occasions that the process of piecing paper together to make collages was related to the two methods he used to make models for bronze sculpture. The small sculptures were made by joining pieces of wax to create a form that was cast by the lost wax process (Fig. 7). For the larger works he constructed armatures on which he built and carved plaster forms that could be cast in multiples (Fig. 8). Bultman wrote in a notebook in the early 1970s:

> For me collage allows great trial and error … that make[s] it akin to sculpture. I cut pieces of wire lathe for armatures of my plaster sculpture and make and tear sheets of wax for my small bronzes. The sheets are interesting for I paint the sheets of paper for my collages and I pour them for sculptures — tearing plays a subsequent role in both.[24]

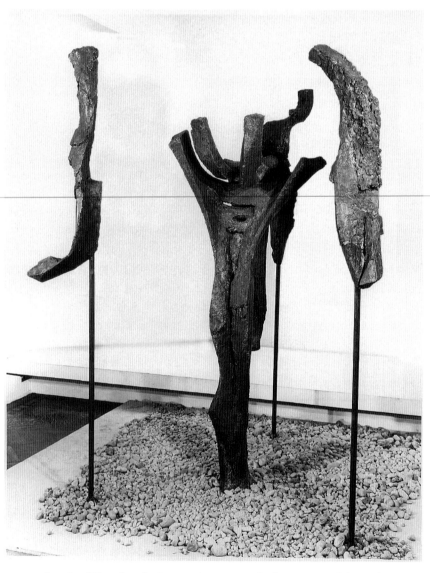

FIGURE 8 *Good News I,* 1963. Bronze, 89 x 62 x 51 inches. Estate of the artist.

When Bultman turned to the two-dimensional "sculptural" medium of collage in the early 1960s, he was enjoying some attention as a sculptor. His first solo sculpture exhibition at Gallery Mayer in 1960 received good reviews, including one by Dore Ashton, who declared him "a gifted sculptor."[25]

The relationships between Bultman's sculpture and collages go beyond process as these works frequently employ the same visual vocabulary. The shapes and linear elements of *Good News I* have virtually identical counterparts in the collages of the period, such as *QUIET!* (Fig. 9). By the 1970s Bultman understood that his works in various media were related by the contours that carved through their respective spaces, whether two- or three-dimensional. He wrote, "To go from a sculpture to a painting now hardly means a shift in attention. They are both so involved in contour that only a change in tools is involved."[26] Positioned as collages are between painting and sculpture, in a material sense, it is understandable that Bultman titled his 1974 show at the Martha Jackson Gallery *Collages: Bridges Between Sculpture and Painting.*

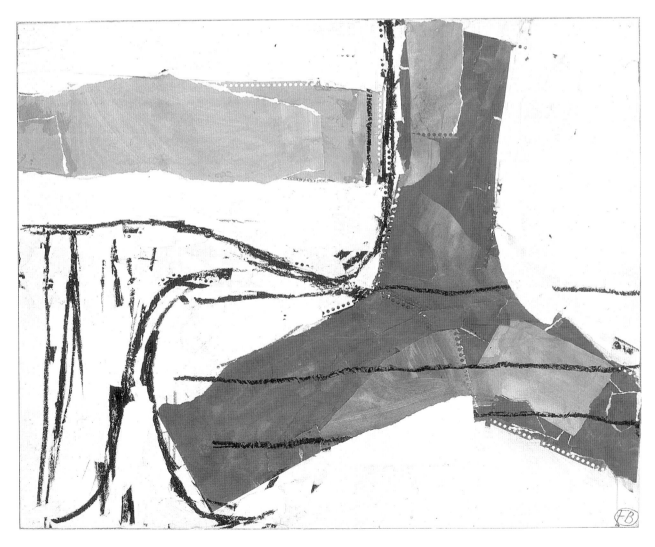

FIGURE 9 *QUIET!, 1962.* Pasted paper, gouache, and crayon, 23 x 29 inches. Collection of Ruth and Jacob Kainen, Chevy Chase, Maryland.

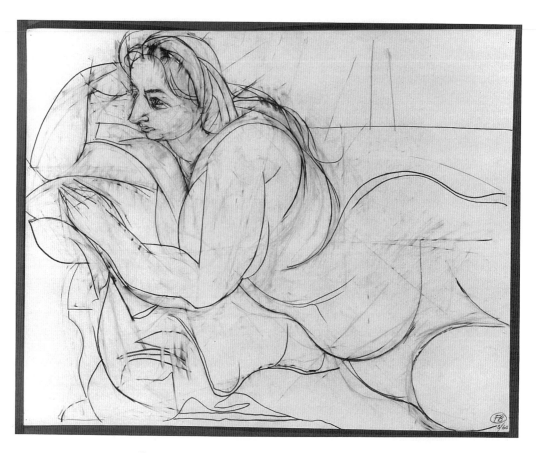

FIGURE 10 *Jo*, 1966. Pencil on paper, 23 x 29 inches. Estate of the artist.

Figure drawing not only heightened Bultman's awareness of contour, but also suggested a number of compositional possibilities. By 1966 drawings such as *Jo* (Fig. 10), with their fluid curves and full volumes, could be translated into the wave-like rhythms of *Ilium* [Plate 5], or worked into more complex forms. In a notebook Bultman precisely described the evolution of forms that derived from his drawing:

> Recently I started a work. It had to do with the rope motive I had observed in drawing the figure, of the twist that the figure takes into space. Over a period of time, this motif and the negative of the motif emerged as a dancing or floating foot or boot, and finally, quite effortlessly—a bird emerged—a floating bird image. But all of this was a long process of several years.[27]

This development from the twisting figure is evident in a number of collages from the late 1960s [Plates 6 and 9], which, typical of their period, retain the substantial presence of drawing.

One of the most persistent images of the 1960s and early '70s is the "Y" shape prominently displayed in *QUIET!* and *Good News I*. Although the central form of the sculptural group might suggest a figure with upraised arms, Bultman frequently identified this shape as a "lap." In this usage the word lap refers to the general conformation of the pelvic region when a figure is seated or bent. Often it is combined with a wave motif [Plate 7], thereby uniting human reference with marine imagery. While Bultman was carried along by a formal investigation of images, the recurrence of

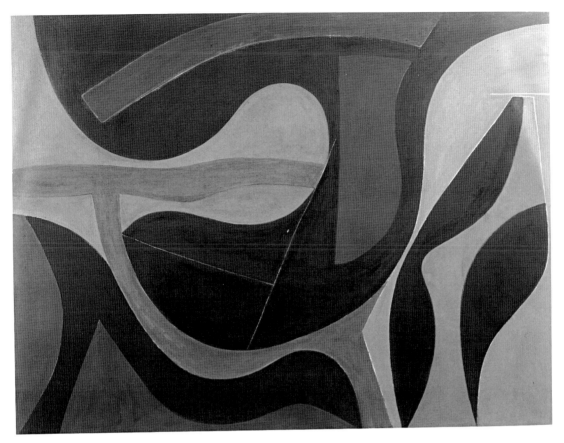

FIGURE 11 *Intrusion of Blue,* 1974. Oil on canvas, 72 x 96 inches. Estate of the artist.

certain forms had deep-seated meanings for him, which will be examined later in this essay. He often said that he disdained the manipulation of materials for their own sake, referring to his images as "messages from the interior world."[28]

Another letter form that appears in Bultman's work in various media is the "T", to which he gave no name. Whatever its deeper significance, this shape serves an important structural function. In two works from 1968, *Explorer: Sky and Earth* (Collection of Donald Windham) and *Explorer: Sky and Water* [Plate 8], Bultman used the "T" shape to determine the physical limits of the collages. These pieces, although still conceived within a rectilinear format, suggested a means to go beyond the rectangle. Three years later Bultman made his first collages "of random shape through random growth" [Plate 10]. From this point the collages grew larger and increasingly commanded his attention.

Although Bultman began as a painter, it is easy to see why he was drawn to sculpture and to a method of collage that resisted confinement. Shapes in his paintings often push against or suggest extension beyond the edges (Fig. 11). The collages allowed him to work without plan and follow shapes wherever they took him. Sometimes, as in *Rooting* [Plate 12], the collages evoke natural forms, and at other times, as in *Blue Line Transforming* [Plate 14], they tend more toward the geometric despite curving contours. In either case, they evolve by an organic process of accretion. *Rooting*, whose title as well as womb-like appearance suggest organic growth, is paradigmatic of Bultman's collage work in the 1970s.

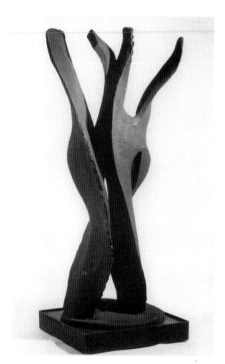

FIGURE 12 *Opening and Closing*, 1975.
Bronze, 67 x 36 x 32 inches.
Estate of the artist.

The dialogue between media, now less frequently involving painting, continued throughout the '70s. The flowing, sharp-edged volumes of *Opening and Closing* (Fig. 12), for example, were translated into two dimensions a few years later in *Mardi Gras* [Plate 16]. Compared to the previous decade, shapes and surfaces in all of Bultman's works are cleaner and smoother. This was a natural development arising out of the emphasis on contours and the planes they enclose. In the case of the collages, the process of clarification was assisted by Bultman's increasing reliance on scissors. In the early 1960s he generally ripped the paper, over time developing extraordinary facility with the torn edge. When he wanted straight edges he could retain the paper's own edge, or tear against a ruler. Both tearing and cutting are evident in the collages of the early 1970s, but the scissors largely took over at the end of the decade. By the 1980s Bultman was also using a roller to flatten the painted paper as he adhered it to the canvas backing. This procedure eliminated the buckling that occurred when he applied several layers of paper. Although the impulse to clarify shapes and smooth surfaces followed a predictable course, it may have become stronger with Bultman's interest in using collage as maquettes for stained glass.

Undoubtedly inspired by Matisse, Bultman's first stained glass windows were made in 1976 for the chapel of his family's funeral home in New Orleans. About transferring collage to stained glass he remarked:

> The step from collage to stained glass is absolutely natural, as Matisse
>
> demonstrated with his windows for the Chapel in Vence. What he did not
>
> show is how intrinsic the lead tracery is. It is the element that adds a draw-
>
> ing to the glowing color of the glass The drawing defines the color as
>
> well as setting up a rhythmical joining.[29]

The windows Bultman created in New Orleans, based on four collages measuring 9 x 3 feet, were fabricated at a factory in New Jersey, but subsequent pieces were made by his wife, Jeanne, who decided she could learn the technique. After taking lessons she constructed a number of windows that were installed mainly in private residences, including their own (Fig. 13). The largest stained glass project is in the lobby of the Light Fine Arts Building at Kalamazoo College in Michigan. In 1981, under Bultman's direction, college students, faculty, school children, and community members pieced together seven collages, each 12 feet x 6 feet, 8 inches, to serve as maquettes for a continuous row of windows above the building's entrances. The windows were installed in sections over the next four years as Jeanne Bultman constructed them.

Collage used as the basis for stained glass returned Bultman's work to fixed boundaries. He made note of this situation in 1979, saying, "In a strange way, the collages that I have worked out with Jeanne for glass are closer to my paintings (oils) than my other collages The window usually is a rectangle of given dimensions."[30] Unable to solve the presentation problem posed by the free-form collages, the rectangular format became attractive again.

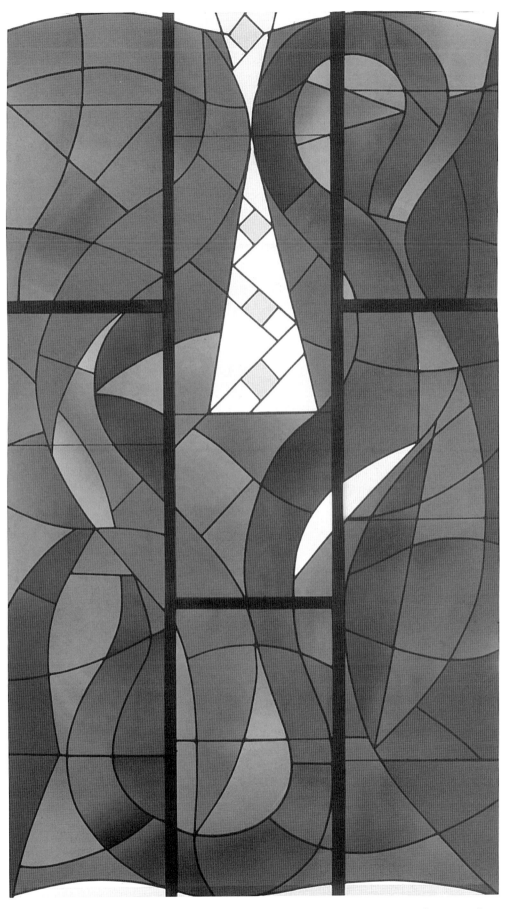

FIGURE 13 *Istanbul-Nightfall Rising,* 1979. Stained glass, 84 x 48 inches. Collection of Jeanne Bultman.

BULTMAN'S AESTHETICS

Looking back over his career in the early 1960s, Bultman noted that his art was about reconciling opposites. He wrote:

> I have a natural tendency toward geometry and symmetry—it is not easy to have this and the flowing curves that I love consciously; to unite these has been the "reason" for my painting and sculpture for the last 15 years—I love everything that flows.[31]

According to Bultman, his inclination to unify opposites could be traced to his childhood. Recalling his conversations with Morris Graves, he told Irving Sandler that, given the limited material available to them, they shared an interest in the work of Paul Gauguin and Nicholas Poussin, an interest that remained with him.[32] Asked how he could reconcile two such different artists, Bultman cited the rich contrasts of his Louisiana boyhood, including the practice of burning swamps: "It's the fire and water. You very seldom see them together in such close juxtaposition as you do when they're burning a swamp."[33]

Whatever Bultman drew from childhood experience was reinforced in his years with Hans Hofmann. Hofmann had been in Paris to witness the developments of Fauvism and Cubism and retained a reverence for Picasso and Matisse. He also placed Miró, Mondrian, Paul Cézanne, and Vasily Kandinsky high on his list of modern masters, and in various ways absorbed their diverse lessons. As William Seitz observed, "Opposition is as operative in Hofmann's work stream as it is in his individual pictures....Indeed, few painters have tried to embrace such contradictory extremes."[34] Bultman, like so many aspiring artists, found Hofmann an ideal teacher, one who encouraged the pursuit of artistic polarities. Years later, sounding very much like his mentor, Bultman wrote, "Plastic art is the internal dialogue of painting—it is painting defining itself in its own terms...a Pollock is as plastically precise as a Mondrian."[35] If, however, Hofmann never committed himself to one manner, Bultman in his later work attempted to reconcile contradictions in a consistent style.

Bultman's love of flowing curves was evident in the décor of his Manhattan brownstone, which he and Jeanne bought in 1956, and in their summer home in Provincetown, where they had lived year-round before they moved to New York in 1952. The Bultmans surrounded themselves with bentwood and horn furniture, Tiffany objects, and an assortment of antlers and horns. Along with his love of curves, the antlers held psychological significance for Bultman because of his strong identification with the Acteon myth. Antlers and horns, especially in pairs, also reveal a pattern of growth from a central point and suggest an underlying geometry, characteristics inherent in Bultman's collages [Plate 4].

At the inception of the new collage series in the early '60s, Bultman made prominent use of the spiral edge of his drawing paper, primarily to reinforce the edges of shapes. He also began placing small pieces of paper in series. When employed together in the same composition, the repetitive intervals of binder holes and collaged tracks of paper correspond to each other [Plate 3]. Bultman had used dots and dashes in some of his

early works, but this practice ceased to feel comfortable to him until his renewed involvement with collage. Laying down substantial tracks in oil painting required a decisive step, whereas collage permitted freedom of repeated adjustments.[36] The sequences of collaged squares are of an intermediate order, functioning as both line and plane. As linear systems the tracks may follow contours or operate independently, and as planes they resonate with larger surfaces. The painter Budd Hopkins saw another dual role for the squares, stating, "Though it may sound contradictory, these little squares provide both a sense of regularity and order— and a new, smaller-scale decorativeness."[37] Hopkins likened the squares that hug the contours of curving shapes to "confetti fastened to boomerangs." This decorative aspect is given new direction in a few works of the late 1970s in which pewter-colored push pins, instruments in the formation of the collages, glimmer against planes of luminous color [Plate 18].

For Bultman, a work succeeded when divergent elements were brought into tenuous unity. Accordingly, he wrote:

Nothing is in itself—only in relation to what is around it—no shape exists—

no form exists—no thought exists except in the "active" field that such an

"event" brings into being—a shape is only the result of shapes, of forces

both within it and those from the surrounding activity.[38]

His goal was to raise all the parts in the composition to a state of fullness by bringing them to the surface, "like a ripe fruit."[39] To achieve these surfaces the pictorial field had to be charged with clear, radiant color.

The effects of color, in the final analysis, are ineffable, which is why Bultman wrote:

We know nothing about our art It is all relative—the relation of space to

color, of color making volume, of color making light, of light being related

to a space, of all color being color only in a relational way. It is so rela

tional a situation as to be useless to assign terms [40]

Nevertheless, he worked with color as if it were any other material, building his collages not simply with paper but with color as corporeal matter. This approach can be traced to Hofmann, who conceived of "pure painting" as "forming with color."[41] Not only is there a similar extravagance of color in the work of both artists, but the attitudes towards color exhibited in Bultman's collages are easily associated with Hofmann's pronouncements on the subject.[42]

According to Hofmann, "color and form develop, one through the other, into a reciprocal, compensatory relationship." The placement of color, which has characteristics "comparable to tone scales in music," leads to "an interwoven communion of color scales over the entire picture surface." The meeting of colors creates a sense of "tensional difference" that Hofmann identified as "simultaneous contrast." "Although tonal development may lead to an overall pictorial harmony," he stated, "it sacrifices simultaneous contrast, which is the predominant quality of

pure painting." To this point Bultman's concepts of color function parallel Hofmann's, but although he agreed with the importance Hofmann placed on the picture plane, he did not, in his writings or work, place as strong an emphasis on the dynamic, shifting qualities of pictorial space Hofmann called "push and pull."

Bultman did subscribe to Hofmann's proposition that, "[i]n nature, light creates the color; in the picture, color creates light," noting himself that "color has to do with converting paint to light."[43] In fact, Hofmann's discussion of pigment as light goes to the heart of Bultman's collage technique. Hofmann wrote,

> Color undergoes in this process still another metamorphosis, in the textural
>
> progression of the work. Texture is the consequence of the general pig-
>
> mentary development of the work, and becomes in this way an additional
>
> light-producing factor, capable of altering the luminosity of the colors in the
>
> pace of their development towards a color-totality.[44]

As Bultman painted drawing pads in preparation for the collages, he avoided flat, even applications of paint, frequently making drawings that he then covered. The varying densities of paint, combined with the innumerable pieces of paper that comprise the collages, create countless light emanations and inflections. Even in his collages of the 1980s, which are considerably flatter in terms of paint application and adhered surfaces, the mosaic of painted papers precludes the possibility of what Hofmann called "only one light meaning" in each color area.

The challenge to reconcile dualities in his collages and to bring their surfaces to a state of fruition was frequently a struggle for Bultman, although he found such encounters exhilarating. Concerning one piece in progress, he noted in a journal, "…resolved part of the red collage—I think that I don't really see it yet—can't get it to mean anything to me—It remains an exercise with very good parts rather than an experience."[45]

CONTENT OF THE COLLAGES

The "experience" Bultman sought in his art was two-fold. He was preoccupied with formal solutions, yet he felt manipulation of materials for their own sake, a practice he associated with the Bauhaus, was not enough.[46] He believed art should relate to personal experience in some way, to the facts and sensations of his life. It is not readily apparent how Bultman's work expresses meaning, and in many instances it seems to have eluded him. Nevertheless, there are a number of personal associations, some relatively straightforward, others deep-seated, that can be connected to his work.

In addition to the daily studio routine, Bultman's days in Provincetown, where he and Jeanne resided about five months a year, were spent working in their garden, swimming off Race's Point, observing the rhythms of nature, and socializing with close friends in the summer art community. The sea and garden provided constant inspiration, as evidenced in the numerous wave images and titles such as *Rooting* and

Garden Spring (New Orleans Museum of Art). In July 1977 Bultman wrote in his journal, "I feel so great when I swim and garden and work like this—almost as though the body is floating at a certain point—floating in a new medium of air...."[47] He acknowledged this sensation in the titles of four collages made in 1980 [Plate 20]. In another entry he wrote, "I always feel lighter physically on clear blue days—troubles evaporate when I can swim and be in the blue pleasure dome of sky."[48] Blue, used sparingly by Bultman before the 1960s, became a dominant color in his later work and the subject of an essay he wrote in 1978.[49] Bultman delighted in watching darkness descend over the landscape and consequently titled two works *Notte* [Plate 24] and *Night Entering the Water* (Provincetown Art Association and Museum). Even an unpleasant aspect of his life—the many sleepless nights—may be reflected in *Ante Luce*, a collage with an unusual black and brown color scheme [Plate 25]. A journal entry reads, "Bad night—fell asleep immediately, awoke at 1:30 a.m.—and was awake until daybreak. Te Ante Luce!"[50] This is not to say that Bultman set out to illustrate his insomnia, the garden, or anything else; rather, life experiences and making art intersected at some point in those works that meant the most to him.

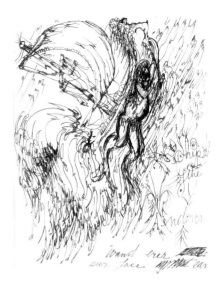

Early in his career Bultman acknowledged the importance of traditional symbols, as did many of his fellow artists in the 1940s. He wrote in the mid-'40s:

> The strongest symbols are those that have evolved over long periods of time: the ✝, the ∞, the Greek alphabet, Chinese characters, the ♀, the 卍. These are cabalistic, protean, and universal. Painting to become universal must release more and more of these magic signs to the spectator.[51]

On several occasions in the 1970s Bultman referred to his use of the "wave of infinity sign."[52] Evident in a number of works starting in the 1940s, the infinity sign frequently appears as an incomplete form in the wave images [Plates 11 and 17]. Another concept he carried into his later work from the 1940s was the association between the sea and the feminine.

In the same notebook from the mid-1940s, in which Bultman commented on universal symbols, he made a drawing of a mermaid as the hull of a ship with tattered sails and a phallic mast (Fig. 14). A rambling discourse which accompanies the drawing, in part, reads:

> The boats, the carriers of men—they are the symbol of the mother, the confinement, a limitation of life like in the womb. The prows are arched like the full stomach of carrying mothers.... The ocean is the mother of all life. The boat becomes the temporary womb. The throbbing of the engines is the pulsation of the blood. On the ship in the womb, the wanderer can reconstitute his life. The safeness and lack of complexity allow the natural instincts to return to their correct order. The ship absorbs the fears and anxieties of the land that holds the wanderer in a frozen trance....[53]

The later inclination to translate the female figure into wave-like rhythms can be connected to this idea, as can several of the wave images that are decidedly womb-like [Plate 19].

The Laps are pertinent in this context. Although the lap shape can be associated with other images, Bultman made a specific identification with the body, once describing it as "comforting, inviting."[54] As emblematic forms associated with the torso, the laps can be interpreted as exterior correlates of the womb. To complicate this reading, however, the lap shape in the 1960s appears with an interlocking wave form that resembles the yin-yang symbol, that is, the symbol of male and female [Plates 7 and 8]. Moreover, the laps themselves may be read as either male or female. Such double-gendered imagery also can be traced back to that notebook of the 1940s in a representation of a hermaphroditic mermaid titled *The Male Female Fish Wombedan*.

Close observers of Bultman's work have remarked on its sexual suggestiveness. Writing about his sculpture in 1976, April Kinglsey dwelled on examples "loaded with sexual overtones," including the three pieces in the Catch series in which "a differently shaped, tall, urgent 'phallus' is caught in a curvilinear saddle."[55] In his review of the 1974 Martha Jackson collage show Douglas Crimp commented, "The persistent upside-down Y shape is sometimes pushed to extreme voluptuousness as spread-eagle torso, adding a touch of eroticism."[56] Steven Schlesinger, whose Manhattan gallery represents the artist's estate, maintains (after looking at the work for years), "It's all about sex."[57]

Even taken as partially true, how do we understand this expression of sexuality? Prior to psychoanalysis in the 1950s Bultman's notebooks indicate that he was deeply troubled about the question of his sexual identity. Not a trace of this conflict is evident in the notebooks and journals after his therapy, which suggests that psychoanalysis enabled him to come to terms with the issue. What, then, of such collage titles in the early 1960s as *Twosome* (Estate of the artist) and *Lovers* [Plate 1], the Laps, and an abundance of phallic and interpenetrating forms in all media? To the extent that his work can be read sexually, such interpretation should recognize the essentially polymorphous nature of Bultman's visual language.

BACK TO THE RECTANGLE

By 1977 it is evident in some of the collages that Bultman was thinking again in terms of the rectangular format. The edges of *Sky Harp* [Plate 15] are uneven, but it is at home in a frame. His concession to the confining edge is increasingly apparent over the next few years, to the point that the edges of many collages parallel the frames. By 1981, in works such as *Reap* and *Other* [Plates 21 and 22], the framing edge has become a major compositional consideration. Shapes extend into compositions from the edges as well as meeting up against them. Some of these works, such as *Bonfire* [Plate 26], retain an internal sense of "random shape through random growth," but they all present themselves as collaged paintings.

Whereas Bultman previously had cut away the excess canvas after his collages defined their own limits, he now had to think about the for-

merly absent areas as positive shapes and pull them into the composi-
tions. In order to reduce figure-ground relationships as much as possi-
ble, he treated these shapes as gleaming white surfaces. When white
became more important in the collages, black also assumed a new role.
Bultman always had used black and white in his paintings and collages,
primarily for value contrast, or to assert a shape with black. In the late
1970s he appears to have fully recognized the potential for black and
white to energize color. He made an entry to this effect in a journal: "I
got quite a few changes in the deep red & ochre collage from Nov.-Dec.
1977—It is now much more sparkling by introducing the white and black
as extreme colors."[58]

Although it might not have seemed possible in the 1970s, many of
Bultman's collages of the 1980s are even bolder. Color, made more vibrant
by the use of black and white, is flatter, and shapes are frequently larger
and more autonomous, which further enhances color's impact. The pull
between material organization and personal meaning was always present
in Bultman's work, but the pictorial challenges of distributing shape and
color on a large scale within the rectangle may have taken precedence. In
these collages his absorption of European modernism, especially the
examples of Matisse and Mondrian (another reconciliation of opposites),
resonates clearly.

By 1984 it was apparent that Bultman was losing his battle with colon
cancer. He continued to make collages, but the work changed. The color
blue—the color of clear days and the sea that always made him feel
lighter—virtually disappeared from his palette. Yellow, red, black, and
white predominate in works of much smaller scale. The title *Interrupted*
[Plate 27] may express Bultman's view of his condition. This picture, more
dependent than most on distinct figure-ground relationships, is full of
discontinuities. The black shape that drops from the top of the composi-
tion, although not a new feature, here seems invasive. A peculiar rectilin-
ear division of the surface occurs on the right side, and on the left the
striped, trunk-like form with its flowing branch appears for the first time
in Bultman's work.

The truncated tree form relates to the six collages in the Daphne
series made in the same year [Plate 28]. All contain a red trunk-like shape
on a yellow ground, undulating branches in dark green or black, and a
heavy, trapezoidal plinth at the base of the composition. Although
Bultman occasionally worked in series, he had not referred to mythology
since the Acteon paintings in the 1940s. As in the case of the Acteon
myth, which had deep significance for him then, it is possible that this
second tale of metamorphosis took on special meaning for Bultman at
another critical juncture in his life.

January Circle [Plate 29], one of three collages made in 1985, with its
wintery title and stark division between color and non-color, lends itself
to a symbolic interpretation of life and death. The black stripes and circle
on the right side can be read as minuses and a zero. Five days before he
died in July 1985, Jeanne took him back to Provincetown.

THERE WAS A BRIEF MOMENT in the early 1950s when Fritz Bultman might have established a solid reputation as an artist in the New York School, but if timing is everything, he didn't have a chance. It is far more complicated than that, of course, although Bultman did not do much to help his career. When he got back in stride later in the decade, there was little stylistically to distinguish his paintings and sculpture, their quality aside. In the 1960s his smallish collages, although bearing every indication of an accomplished artist, would have been easy to overlook, had they been shown. The monumental collages that followed, built on the European modernist tradition of Hofmann, Matisse, Mondrian, perhaps Arp and Miró as well, and the legacy of the early New York School, probably could not really be seen, even though they were "almost prodigal in their brilliance." They had too little to do with the issues that preoccupied the art world or with a recognizable name.

Since their invention by Picasso and Braque in 1912, the techniques of collage and *papier collé* have enabled artists to produce a wide range of work, but a couple of directions predominate. One basic approach is constructivist, which often plays on the poetic qualities of ephemeral materials. The other direction is illusionistic, and frequently surrealistic. Matisse's late cut-paper works introduced a new way of thinking about *papier collé*, and a new color and scale. Fritz Bultman was Matisse's heir in this realm, although his method was significantly different. Even in his later works that began with fixed boundaries, compositions were developed without premeditation by a process of accretion. Matisse thought of *papier collé* as "drawing with scissors," whereas Bultman saw collage in closer relation to sculpture.

Bultman's emotional life was always volatile, even in his later years. As he grew older, however, he found real joy working in his studio, something he did not always experience in his youth. After a long, productive summer day in 1978 working on collage, he wrote, "It is so much fun to do it…I really have to be forced away from it by exhaustion."[59] The beauty of the collages is the joy they transmit.

EVAN R. FIRESTONE
PROFESSOR OF ART HISTORY
LAMAR DODD SCHOOL OF ART
UNIVERSITY OF GEORGIA

ENDNOTES

Douglas Crimp, "Fritz Bultman," *Artnews* 73 (March 1974): 99-100.

[2] April Kingsley, "Motherwell, Bultman and Ross Uptown," *Soho Weekly News*, 29 January 1976, 19.

[3] Hilton Kramer, "Art: Fritz Bultman Restates His Metaphors," *New York Times*, 24 January 1976, 22.

[4] Robert Motherwell to Jeanne Bultman, 11 October 1988, quoted in April Kingsley, *Fritz Bultman: A Retrospective* (New Orleans: New Orleans Museum of Art, 1993), 9.

[5] Journal, 21 July 1978, Bultman Papers, Archives of American Art, Smithsonian Institution, Washington, D.C. (hereafter referred to as Bultman Papers, AAA).

FRITZ BULTMAN: COLLAGES 34

Motherwell bought the collages at Long Point Gallery, a cooperative gallery in Provincetown, Massachusetts, of which he and Bultman were members.

6 See Kingsley, "Fritz Bultman," in *Fritz Bultman: A Retrospective*, 16-17 for a brief formal analysis of the collages.

7 William Rubin, *Picasso and Braque: Pioneering Cubism* (New York: The Museum of Modern Art, 1989), 36.

8 Bultman Papers, New York, maintained by Jeanne Bultman. Bultman kept notebooks listing works in various media by year. These records, however, are not always complete, especially in the cases of smaller works. Bultman also began recording his thoughts in notebooks about 1939-40. A number of these notebooks and other papers were donated to the Archives of American Art during his lifetime. Consequently, a large collection of journals, letters, various records, and other materials currently is divided between New York and Washington, D.C.

9 Fritz Bultman, "A Statement on Collage," *Cornell Review* 6 (Summer 1979): 43.

10 For a technical discussion of the collages, including methods of mounting them, see John and Joan Digby, *The Collage Handbook* (London and New York: Thames and Hudson, 1985), 105-106. However, according to Jeanne Bultman, the Digbys are wrong about her husband applying a layer of PVA on the collages and then painting them with a final layer of tempera color.

11 Catherine Gammon, "Bultman's big, bright collages," *The Advocate Summer Guide* (Provincetown, Mass.), 20 August 1981, 17.

12 The family residence was on Louisiana Avenue behind the funeral home. Unless otherwise noted the biographical information in this section is drawn from Evan R. Firestone, "Fritz Bultman: The Case of the Missing 'Irascible,'" *Archives of American Art Journal* 34 (1994): 11-20.

13 Notebook, dated "Late 1970s," unpaginated, Bultman Papers, New York.

14 Transcript of tape-recorded interview by Irving Sandler, 6 January 1968, 4, Bultman Papers, New York. The thirty-eight-page typescript, hereafter referred to as the Sandler interview, also is on file at the Archives of American Art. April Kingsley edited and abridged the typescript, presenting it as "Fritz Bultman: On His Influences," in *Fritz Bultman: A Retrospective*, 22-31. Bultman recalled the year of Morris Graves's visit as 1931, but the Graves literature places the date of his trip to New Orleans as 1932; see, for example, Morris Graves, *The Drawings of Morris Graves*, ed. Ida E. Rubin (Boston: New York Graphic Society; published for The Drawing Society, Inc., 1974), 152.

15 Sandler interview, 10.

16 Evan R. Firestone, "Fritz Bultman's Collages," *Arts Magazine* 56 (December 1981): 63. Although Bultman would not have returned, the New Bauhaus closed at the end of its first year of operation.

17 Bultman's parents remained opposed to their son pursuing an uncertain career in art, but were persuaded by Hofmann to give him a chance. In a letter dated 9 July 1938, Hofmann wrote the Bultmans, "I consider him talented…no obstruction can prevent one from becoming an artist….In the case of Fritz I feel able to give my support and to say to you that you must expect Fritz to finally become an artist" (Bultman Papers, AAA). The official biography has Bultman studying with Hofmann from 1938 until 1941, but he was a student when his wife Jeanne, who modeled for Hofmann's Provincetown summer session in 1942, met him.

18 In addition to Firestone, "Fritz Bultman: The Case of the Missing 'Irascible,'" see B. H. Friedman, "'The Irascibles': A Split Second in Art History," *Arts Magazine* 53

(September 1978): 96-102. The fifteen artists who appeared in the photo were Barnett Newman, William Baziotes, James Brooks, Willem de Kooning, Jimmy Ernst, Adolph Gottlieb, Robert Motherwell, Jackson Pollock, Richard Pousette-Dart, Ad Reinhart, Mark Rothko, Theodoros Stamos, Hedda Sterne, Clyfford Still, and Bradley Walker Tomlin. The two other artists who missed the photo session were Weldon Kees and Hans Hofmann.

19 Bultman always said he went to Italy to study bronze casting, but apparently he originally intended to study stone carving. This is stated in a letter of February 1951, written in Paris (unmailed original or hand copy) to a Mrs. Middleditch of the Institute of International Education, Bultman Papers, New York.

20 According to Jeanne Bultman, who was in Europe with her husband from September 1950 to February 1951, the unfinished chapel was not yet open to the public, and in order to gain admission they had to go next door to the convalescent home run by the Dominicans.

21 The Bultmans' copy of *Jazz* was given to them around 1952 or 1953 by Tony Smith, who knew Fritz from the Chicago Bauhaus. According to Jeanne Bultman, Smith purchased the portfolio at the Museum of Modern Art for one hundred dollars.

22 For a fuller account of Bultman's psychological condition and its impact on his art and career in the 1940s and 1950s, see Firestone, "Fritz Bultman: The Case of the Missing 'Irascible.'"

23 Firestone, "Fritz Bultman's Collages," 64.

24 Red Notebook, dated "1970-71," unpaginated, Bultman Papers, New York. There are a few dated entries.

25 Dore Ashton, "Art: A Painter Turns to Sculpture," *New York Times*, 29 January 1960, 16.

26 Red Notebook, dated 1970-71, unpaginated, Bultman Papers, New York.

27 Ibid. This passage appeared in Robert Huot, *Works by Fritz Bultman* (New York: The Bertha and Karl Leubsdorf Art Gallery, Hunter College, City University of New York, 1987), 7.

28 Ibid.

29 "Landmark Gallery Presents 5 1/2 Artists: Joellen Hall, Nora Speyer, Leatrice Rose, Jane Piper, Fritz and Jeanne Bultman," (New York: Landmark Gallery, 1979), 6, Bultman Papers, New York.

30 Ibid.

31 Notebook labeled "Hospital Notebook 1963 - Paris 64. F.B.," unpaginated, Bultman Papers, New York.

32 Sandler interview, 5.

33 Ibid., 7, 8. Bultman's personality also was a contrast of opposites. B. H. Friedman wrote, "Fritz Bultman was one of the most complex men I have known—at once, generous and acquisitive, calm and temperamental, snobbish and democratic, loyal and vindictive, religious and heretical, slow-spoken and quick-witted," in B. H. Friedman, "In Memoriam: An 'Irascible,'" *Arts Magazine* 60 (January 1986): 78.

34 William C. Seitz, *Hans Hofmann* (New York: Museum of Modern Art; distributed by Doubleday and Company, 1963), 43. For an extended discussion of the synthesis of dualities in Hofmann's work, see Irving Sandler, "Hans Hofmann: The Dialectical Master," in *Hans Hofmann*, ed. Cynthia Goodman (Munich: Prestel; distributed by Neues Publishing Company, 1990), 77-96.

35 Red Notebook, early 1970s, Bultman Papers, New York. This is a second red notebook from this period.

36 Bultman would probably have known that Mondrian, for whom he professed great admiration, used painted tape to plot his pictures, in effect making temporary collages until the compositions were translated into paint.

37 Budd Hopkins, "The Collages of Fritz Bultman," *Provincetown Arts* 2 (1986): 11.

38 Statement on Bultman's Provincetown letterhead, n.d., Bultman Papers, New York.

39 Firestone, "Fritz Bultman's Collages," 65.

40 Huot, 16.

41 Hans Hofmann, "The Search for the Real in the Visual Arts," in *Search for the Real and Other Essays*, ed. Sarah T. Weeks and Bartlett H. Hayes Jr. (Andover, Mass.: The Addison Gallery of American Art, 1948), reprinted in Sam Hunter, *Hans Hofmann* (New York: Harry N. Abrams, Inc., 1963), 41.

42 The following summary of Hofmann's analyses of color is based on "The Color Problem in Pure Painting—Its Creative Origin," which originally appeared in the Hans Hofmann exhibition catalogue, Samuel Kootz Gallery, November 7-December 3, 1955. This essay was reprinted several times, including in Hunter, 46-48.

43 Red Notebook, 1970-71, unpaginated, Bultman Papers, New York.

44 Hunter, 46.

45 Journal, 9 July 1977, Bultman Papers, AAA.

46 Firestone, "Fritz Bultman's Collages," 64.

47 Journal, 28 July 1977, Bultman Papers, AAA.

48 Journal, 4 September 1977, Bultman Papers, AAA.

49 "Lecture on Blue," six-page typescript dated 14 November 1978, Bultman Papers, New York.

50 Journal, 25 June 1977, Bultman Papers, AAA. The ungrammatical Latin is a little enigmatic, but it can be awkwardly translated as "you before dawn."

51 Notebook, dated "1942-3 or 1945" on front cover and "1945" on back cover, Bultman Papers, New York. Quoted in Huot, 9.

52 For example, in his Journal, 22 October 1977, Bultman Papers, AAA.

53 Notebook, dated "1942-3" or "1945" on front cover and "1945" on back cover, Bultman Papers, New York. Quoted in Huot, 11, and Kingsley, *Fritz Bultman, A Retrospective*, 35, in sections of their catalogues that present excerpts of Bultman's writings. This notebook and several others from the 1940s and early 1950s present a man struggling to preserve his psychological equilibrium.

54 In conversations with the author; also see Firestone, "Fritz Bultman's Collages," 64.

55 April Kingsley, "Opening and Closing: Fritz Bultman's Sculpture," *Arts Magazine* 50 (January 1976): 83. For sculpture, also see Donald Kuspit, "Fritz Bultman" *Artforum* 26 (November 1987): 130, who noted, "*Coat of Male, 1963/73* is particularly ambitious, with its horns and other phallic elements, one a quite obvious, flattened penis."

56 Crimp, 100.

57 Debbie Forman, "Fritz Bultman Comes Home," *Cape Cod Times*, 17 September 1994, 2 (C), and in several conversations with the author.

58 Journal, 10 February 1979, Bultman Papers, AAA.

59 Journal, 15 August, 1978, Bultman Papers, AAA.

Fritz Bultman, Provincetown, 1942.

FRITZ: SKETCHES

—1—

FRITZ

He liked merchant marines and Matisse drawings of female nudes.
The poetry of Saint John of the Cross and palm leaf pastries.
Provincetown. *The Golden Bough* and Gypsy Rose Lee. The novels of
Ronald Firbank.

Working.

Friendship and feuds.

Drawn with equal force to comfort and confrontation, his behavior
was as contradictory as his tastes. He created physically pleasant habitats
and picked fights to stage in them—thunderstorms to unleash in rooms
bright with white walls, Miró prints, books, driftwood tables. Not speaking
for a year or two was often a part of friendship with him.

He liked people; but after a certain point he did not know how to draw
closer except through antagonism, a legacy from the family scenes and
carryings-on with his mother and father and sister in New Orleans dur-
ing his childhood.

He would watch for your traits and gleefully tease you with them in
order to work himself into the closeness of hostility, the intimacy of a
fight. Dealing with him could become internecine warfare, a battlefield;
he often seemed to embrace the definition of peace as "a purely negative
condition." But his victory was not to banish; it was to engage, to consoli-
date. Even in small things. He wanted tea; you wanted a drink. You would
have tea, followed by an old fashioned.

Fritz's paintings and drawings sometimes reflected this, fighting
against themselves on canvas and paper, to contain and order the warring
elements, not to eliminate them, to subdue and keep them in balance.

His easy and open friendliness, however, his joy in people, was what
you were aware of when you first met him. He and Tennessee Williams
came to know each other in Provincetown during the summer of 1941;
and it was Fritz's outgoing enthusiasm and good humor, rather manic,
that I was most aware of when Tennessee introduced me to him on their
arrival in New York that fall.

Tennessee could draw people close with his seemingly boundless
friendship and keep them that way for years, concealing his resentments
and suspicions behind his smiles. Not so Fritz; he wanted to dig beneath
the surface. He challenged. With each of them, it was easy to misread his
intentions; each often appeared the opposite of what he was; and,
although it took me years to realize it, they each remain a part of my
early discovery that appearances, like categories, mislead.

PROVINCETOWN

This fishing village at the tip of Cape Cod has been, at least since 1900, as contradictory a combination of elements as Fritz's character. The main inhabitants are Portuguese fishermen. The most popular entertainer in the 1950s at Weathering Heights, a nightclub near the west end of town, was Phil Bayonne, a female impersonator in a floppy hat and garden dress, who descended from the flies to the stage seated in a swing suspended by flower-wreathed ropes and delighted his audience of fishermen and their wives into roaring with appreciation, "He's a little bit of you, a little bit of me!"

Summertime during the early years Fritz and Tennessee were in Provincetown, the population expanded into noisy swarms of vacationing young men, delineated by Fritz as "ribbon salesmen from behind their counters at Saks and Bergdorf," by Tennessee as "belles tinkling all over town, in their baby-blue shorts and flowered sarongs." With autumn, the population shrank again to the year-round fishermen, carpenters, boatwrights, a scattering of artists, painters and writers, the winter silence.

Provincetown in the summer of 1942 was also where Fritz met his future wife, Jeanne. They were married at the end of 1943 in a simple ceremony at St. Patrick's Cathedral in New York; but they returned the following spring to Provincetown and managed to buy a lot, with a small, crude wooden shack on the top of its hill, near the center of town. Not, however, with money from Fritz's well-to-do father; he disapproved of his son's marrying a young woman who had been a burlesque dancer on Forty-Second Street; but from Jeanne's mother who, when she learned of their wedding, sent Jeanne the little over a thousand dollars she had put aside for her to have a proper wedding at home in Hastings, Nebraska, like those of her sisters.

That summer, Fritz and Jeanne rented rooms in the house of Peter Hunt, a local artist. Part of the time, they let Tennessee stay with them and use their typewriter, despite the fact that he and Fritz had all but ceased speaking to each other the winter of 1942. Fritz had put Tennessee up in his Greenwich Village apartment and Tennessee, with his usual tendency to make a mess of other peoples' places, had more or less destroyed it.*

But that winter had also formed a tenuous solidarity between them. Penniless, Tennessee had been working at Valeska Gert's Beggar's Bar as a poetry-reciting waiter. One night she confiscated his tips, his only pay, and he got into a fight with her. Fritz, who had persuaded me to dance with him specifically to annoy Valeska, happily joined in, throwing chairs around the room and smashing soda bottles against the walls of the basement establishment.

* "Poor Fritz. Who holds me directly or indirectly responsible—mostly directly—
 for the destruction of his electric percolator, loss of electric razor, permanent
 damage to central nervous system." *Tennessee Williams' Letters to Donald Windham,
 1940-1965* (Athens, Georgia: University of Georgia Press, 1996), 131.

Provincetown, the summer of 1945, also held Tony Smith, an old friend of Fritz's, who was beginning to work on the studio he had designed for Fritz, to be built at the bottom of the hill. But before this was finished, the shack at the top had been transformed by Fritz and Jeanne into the kind of place Fritz liked to live.

One room. The walls white. Windows on three sides. A wide arch flanked by bookshelves on the fourth. Beneath one window, a table; under the table, two wicker storage baskets; and beneath the other windows, blue denim seats piled with red and blue denim pillows. From wherever you lay or sat, you looked out onto tree tops, housetops, the harbor and boats, the sky and clouds. A glass door to the three-sided porch opened between the windows on the front wall. Over the arch at the back, an entresol sleeping loft was reached by a ladder that could be hooked flat against the ceiling, out of sight, or lowered to the floor in the middle of the room. A red wooden chest there doubled as more storage space and a table. A closet door on one side of the arch, a black-and-white Miró print above the Ivanhoe stove on the other; a narrow opening to a tiny kitchen and bath.

I have left out the Calder fish, added in 1945. It hung from the ceiling, above head height, in the center of the room. A simple outline in a single piece of red metal tube, the mouth open, the eye a perfect circular loop, the scales of thinner wire, a piece of glass or mirror, red or green shard of bottle in each scale, a round green bottle bottom for the wide-open eye, thirty-six bright jewels in all.

—3—
FRIENDSHIPS

Fritz got along with other artists, painters and writers; he did not get along with art dealers.

With gallery owners, an echo of his dealings with his father seemed to take over. He managed all right with Alexander Iolas of the Hugo Gallery, where he exhibited in the late 1940s and early 1950s; Iolas was too campy and flamboyant to upset him, even when they disagreed. But Fritz did not have an easy time with most dealers. Once work was desired or demanded of him by someone who presumed authority, he became tortured by an inability to give what he willingly and happily gave otherwise. He seemed to know this—in the way that one knows facts about oneself, from a different angle than that from which other people know them—but this only made him more likely to withdraw into depression.

Late in the 1950s in Provincetown. The "shack" had been enlarged a few years earlier with a spacious cinder-block main room. The studio was a comfortable place to live as well as to work. Fritz and Jeanne, their sons Anthony and Johann, Sandy Campbell and I, had come up for the Thanksgiving holidays. Whoever the dealer was with whom Fritz was in conflict at the time, by Thanksgiving day he had worked himself into such a gloom that, down in the studio, where he had slept, he refused to get out of bed. No matter who tried, no approach roused him all day long. It was after dark when Sandy and Anthony finally determined, if they could, to get him out of his depression before dinner, went down and sat

beside him on either side of the bed, Sandy carrying along a glass of whiskey which he repeatedly placed before Fritz, or waved under his nose, each time he rejected it until, at last, they cajoled him into getting dressed and coming up the hill.

But, even with the artists with whom he got along, Fritz found it possible to bring about a clash of egos from which to draw the tension necessary for creation.

One summer in the late 1970s, during which he was feeling a general sense of uprising, had exhibited in the Art Association's potpourri show of all the painters who had worked in the Lumber Yard studios at Provincetown since 1917, from Charles Demuth to Hans Hofmann; had produced his first silk-screen poster for the Association; and from the gallery he had started with other painters, had sold a number of his collages to young artists, to Robert Motherwell, and to a curator at the Metropolitan Museum, so that he had been in the full bloom of working and living, and felt almost too well, he managed at a party to pick a fight—a "thing" as he called it—with Stanley Kunitz's wife Elise over a chance remark, and so was ready the next morning to shut himself up again with his work.

—4—

Sometimes I wonder how all those who do not write, compose or paint can manage to escape the madness, the melancholy, the panic fear which is inherent in the human situation.

GRAHAM GREENE

To stay in the Bultmans' house in either Provincetown or New York was to read Fritz's library. Not the two or three books I have mentioned, but hundreds; the volumes of many other authors than the ones I knew well; more poetry by Ovid, Rilke, Péguy, Apollinaire, Baudelaire, Pound; the books of writers Fritz introduced me to, Baron Corvo, Jane Harrison, Otto Rank, Carl Jung, etc.; the passages with subjects he knew I was interested in.

It was one spring on the Cape that he pointed out to me in Hugh Ross Willamson's *The Arrow and the Sword*: "Nor, of the thousands who have publicly yearned 'to meet their pilot face to face when they have crossed the bar' (and Tennyson's poem is included in *Hymns, Ancient and Modern*) have the majority probably been aware that the pilot is not God but Arthur Hallam."

Reading was not the main bond between us, however. It was "work"; not the subject matter of work, but "work" itself. The need some people have and others do not. The necessity that comes from some place inside, unknown to us. A desire that even the comfort of other people does not enable us to escape; and that, without our knowing why, we allow to make us, in spite of our dissimilarities and different aims, "people in the same boat."

Work draws upon and is an escape from the whole range of the human situation. Here is part of a letter that Fritz wrote from

Provincetown one May when both he and I were having trouble with the worldly acceptance of our work, half a dozen years before the elated summer in the late 1970s, described above:

Thurs. A.M.

Dearest Don and Sandy–

The shad is in full bloom today and it is still and sunny, yet the fog hangs in patches and the siren or rather the horns keep blowing. In other words, the most beautiful of spring days. The horns are set at various points along the beach and so they play antiphonally against each other. You would enjoy it here. Even my gouty foot cannot destroy these pleasures—but gouty it is.

This is an uncomfortable visit here. I've tried to do things for which I'm incapable instead of just getting into my studio and working, which is what I want to do. To work and to walk. Thank you for the card, Sandy. I think my work is still growing and so I'm very happy if I could just get to it, instead of fussing with houses and dealers etc. The rhythm of work has been destroyed and so I fuss and bring on the gout. I've grown into some sort of "religieux de travail," who can only enjoy working. I still go to parties when I'm alone particularly, just to know life goes on, and I've discovered something to do since I can't drink. I played bartender at a big party the Mailers gave and quite enjoyed myself. Time doesn't hang so heavy at parties then. When Jeanne is here, I don't go. I hear about them, which I enjoy more. By the way, Jeanne tells me, Don, that you are very down still. Just the ailments of middle age are insults enough without the infirmities and assaults our work has to absorb. There is a strange dilemma here…I have long ago realized that your position, like mine, was untenable in the face of worldly acceptance and that the price of independence was obscurity. You must realize that character-wise you cannot make any other choice. Also there is no redemption thru time like in the 19th cent. It is only thru work that pleasure/reward will come to us, to make work the be all and the end all in itself. Anytime that the glib-tongued come offering success and recognition realize that these are shadow fruit. The only success is that you can give yourself thru creation. I know this is a bleak offering but at least it is compatible with the reality of life and with your character. After this reward everything else is an anticlimax. It is not that we would not enjoy recognition of our work but not at the price that the marketplace demands. I love the world and many people in it. We must try to reach them, up to a point, and that point is the continuation of working.

DONALD WINDHAM
NEW YORK CITY

FRITZ BULTMAN: COLLAGES

BIOGRAPHICAL NOTES

1919 Born April 4, New Orleans, Louisiana.

1932 Morris Graves visited New Orleans in the summer and stayed with the Bultman family. Bultman and Graves spent considerable time together, talking about art and sketching in Audubon Park.

1935-37 Traveled to Munich, Germany, with a high-school junior year aboard program; he dropped out of the program but lived with Hans Hofmann's wife Maria while attending a preparatory school.

1937-38 Attended the New Bauhaus in Chicago, Illinois. Became friends with Tony Smith, who was an architecture student at the school.

1938-42 Studied painting with Hans Hofmann in Provincetown, Massachusetts, and New York City. Associated with a literary-artistic circle in the early 1940s that included Tennessee Williams and Donald Windham.

1943 Married Jeanne Lawson, who modeled for Hofmann's Provincetown summer session in 1942.

1945-52 Lived in Provincetown; Tony Smith designed a five-sided, vaulted studio for him.

1947 First New York exhibition at the Hugo Gallery, and first newspaper review, which appeared in the *New York Herald Tribune*.

1949 One of the principal organizers of *Forum 49*, a summer exhibition of contemporary art in Provincetown accompanied by lectures, panel discussions, and films.

1950 Solo exhibition at the Hugo Gallery. Participated in the *Black or White* exhibition at the Samuel Kootz Gallery, New York City, which included famous European artists and rising Americans. Represented in the *Annual Exhibition of Contemporary American Painting*, Whitney Museum of American Art, New York.

Signed letter protesting the exhibition policies of the Metropolitan Museum of Art that was published in the *New York Times* on May 22. The eighteen signatories became known as "The Irascibles."

Received a grant by the Institute of International Education to study sculpture techniques in Italy; departed for Italy September 1950, returned June 1951. While in Europe visited the Chapel of the Rosary of the Dominican Nuns in Vence, France, to see Henri Matisse's design work for the chapel.

1951 Formally joined the Samuel Kootz Gallery; Kootz sold Nelson A. Rockefeller a large painting titled *Tides*.

1952 Moved to New York City and began psychoanalysis. Participated in the Whitney Museum of American Art's *Annual Exhibition of Sculpture, Watercolors and Drawings*. Solo exhibition at the Samuel Kootz Gallery in September. Participated in *Fifth Annual Exhibition of Contemporary Painting*, University of Illinois, Urbana.

1953-56 Continued psychoanalysis until November 1956, during which time he executed very little work. Nevertheless, he exhibited a painting in the Whitney Museum of American Art's *Annual Exhibition of Paintings, Sculpture, Watercolors and Drawings* in 1955.

1958 Solo exhibition of paintings at the Stable Gallery, New York City.

1959 Solo exhibition of paintings at the Martha Jackson Gallery, New York City. Exhibition of paintings and sculptures at the Delgado Museum of Art, New Orleans. Began teaching at Hunter College in Manhattan; remained on the faculty until 1964.

1960 Solo sculpture exhibition at Gallery Mayer, New York City. Exhibited paintings at Galerie Stadler, Paris, France. Represented in *Sixty American Painters*, organized by H.H. Arnason for the Walker Art Center, Minneapolis.

1962 Began working in collage using paper painted with gouache.

1963 Solo sculpture exhibition at Tibor de Nagy Gallery, New York City.

1964 Solo exhibition of paintings at Tibor de Nagy Gallery. Received award for sculpture in *Sixty-Seventh American Exhibition*, at the Art Institute of Chicago. Awarded a Fulbright Fellowship for study in Paris; worked in Paris from June 1964 to June 1965.

1965 Solo exhibition at the Arts Club of Chicago.

1968 Co-founded the Fine Arts Work Center offering residencies for young artists and writers in Provincetown.

1970 Included in *American Painting 1970*, Virginia Museum of Fine Arts, Richmond.

1974 Solo exhibition at the Martha Jackson Gallery titled *Collages: Bridges Between Sculpture and Painting*.

1975 Received a Solomon R. Guggenheim Fellowship for sculpture.

1976 Solo exhibition of collages and sculpture at the Martha Jackson Gallery.

1977 One of the founding members of the Long Point Gallery, a cooperative gallery in Provincetown. Some of the early members of the gallery included Varajan Boghosian, Budd Hopkins, Leo Manso, Robert Motherwell, Paul Resika, and Judith Rothschild.

1978 Traveled to Turkey, realizing a long-held ambition to see the Hagia Sophia. Solo exhibition at the Andre Zarre Gallery, New York City.

1979 Exhibited collages and a stained glass window made by Jeanne Bultman based on his collage at the Landmark Gallery, New York City.

1981 Solo exhibition at the Barbara Fiedler Gallery, Washington, D.C. Supervised the construction of seven collages, each 12 feet x 6 feet, 8 inches, by college students and faculty, school children and members of the community at Kalamazoo College in Michigan. These collages served as maquettes for stained glass windows in the Light Fine Arts Building. The windows were installed over the next four years as Jeanne made them.

1982 Solo exhibition at Gallery Schlesinger-Boisanté in New York City. Subsequent exhibitions in this gallery held in 1986 and 1987. Gallery Schlesinger has represented the estate of the artist and presented annual exhibitions since 1989.

1984 Traveled to Sicily to see antiquities from period of early Greek colonization.

1985 Died July 20 in Provincetown, Massachusetts.

CORPORATE, EDUCATIONAL AND PUBLIC COLLECTIONS

ARCHER M. HUNTINGTON ART GALLERY
University of Texas at Austin

ARKANSAS ARTS CENTER
Little Rock, Arkansas

ART INSTITUTE OF CHICAGO
Chicago, Illinois

BOWDOIN COLLEGE MUSEUM OF ART
Brunswick, Maine

BRISTOL-MYERS SQUIBB COMPANY
Lawrenceville, New Jersey

CIBA-GEIGY CORPORATION
Tarrytown, New York

ENTERGY CORPORATION
New Orleans, Louisiana

GOLDRING INTERNATIONAL
Woodbury, New York

GREENVILLE COUNTY MUSEUM OF ART
Greenville, South Carolina

GREY ART GALLERY AND STUDY CENTER
New York University

GRINNELL COLLEGE
Grinnell, Iowa

HUNTER COLLEGE OF THE CITY
UNIVERSITY OF NEW YORK
New York, New York

KALAMAZOO COLLEGE
Kalamazoo, Michigan

MCCRORY CORPORATION
New York, New York

METROPOLITAN MUSEUM OF ART
New York, New York

MINNESOTA MUSEUM OF ART
Saint Paul, Minnesota

MOBIL CORPORATION
Fairfax, Virginia

MONTCLAIR MUSEUM OF ART
Montclair, New Jersey

MUSEUM OF ART, RHODE ISLAND SCHOOL OF DESIGN
Providence, Rhode Island

MUSEUM OF FINE ARTS
Boston, Massachusetts

MUSEUM OF WESTERN VIRGINIA
Roanoke, Virginia

NATIONAL MUSEUM OF AMERICAN ART,
SMITHSONIAN INSTITUTION
Washington, D.C.

NEW ORLEANS MUSEUM OF ART
New Orleans, Louisiana

OGDEN MUSEUM OF AMERICAN ART
New Orleans, Louisiana

PORTLAND MUSEUM OF ART
Portland, Maine

PROVINCETOWN ART ASSOCIATION AND MUSEUM
Provincetown, Massachusetts

PRUDENTIAL INSURANCE COMPANY
Newark, New Jersey

ROSE ART MUSEUM,
BRANDEIS UNIVERSITY
Waltham, Massachusetts

SHELDON MEMORIAL ART GALLERY
AND SCULPTURE GARDEN
University of Nebraska, Lincoln

SOLOMON R. GUGGENHEIM MUSEUM
New York, New York

TULANE UNIVERSITY
New Orleans, Louisiana

UNIVERSITY ART MUSEUM
University of California at Berkeley

WEATHERSPOON ART GALLERY
University of North Carolina at Greensboro

WHITNEY MUSEUM OF AMERICAN ART
New York, New York

WILLIAM BENTON MUSEUM OF ART
University of Connecticut, Storrs

WILLIAMS COLLEGE MUSEUM OF ART
Williamstown, Massachusetts

SELECTED BIBLIOGRAPHY

BOOKS

Digby, John and Joan Digby. *The Collage Handbook.* New York: Thames and Hudson, 1985, 105-107.

Kingsley, April. *The Turning Point.* New York: Simon and Shuster, 1992, 83-86.

LeClair, Charles. *Color in Contemporary Painting.* New York: Watson-Guptil Publications, 1991, 125-127.

Rand, Harry. *Martha Jackson Memorial Collection.* Washington, D.C.: Smithsonian Institution Press, 1985, 21-26.

Sedgwick, John P. *Discovering Modern Art.* New York: Random House, 1966, 159-166.

EXHIBITION CATALOGUES

Arnason, H. H. *Sixty American Painters.* Minneapolis, Minnesota: Walker Art Center, 1960, 53, 58.

Bell, Tiffany, Irving Sandler, and Dore Ashton. *After Matisse.* New York: Independent Curators, Inc., 1986, 10, 54.

Doudera, Gerald. *Fritz Bultman Collages, Drawings, and Sculptures from Two Decades, 1960-1980.* Storrs, Connecticut: William Benton Museum of Art, University of Connecticut, 1989.

Friedman, Sanford. *The Glad Tidings of Fritz Bultman.* New York: Martha Jackson Gallery, 1975.

Huot, Robert. *Works by Fritz Bultman.* New York: The Bertha and Karl Leubsdorf Art Gallery, Hunter College, City University of New York, 1987.

Kingsley, April. *Fritz Bultman: A Retrospective.* New Orleans: New Orleans Museum of Art, 1993.

Landmark Gallery. *Landmark Gallery Presents 5 1/2 Artists: Joellen Hall, Nora Speyer, Leatrice Rose, Jane Piper, Fritz and Jeanne Bultman.* New York: Landmark Gallery, May 1979, 6.

Sandler, Irving. *The Irascibles.* New York: CDS Gallery, February 1988, unpaginated.

Tapié, Michel. *Neue Malerei: Form, Struktur, Bedeutung.* Munich, Germany: Stadtische Galerie, 1960, unpaginated.

Weller, Allen S. *Contemporary American Painting and Sculpture.* Urbana: University of Illinois, 1953, 171-172.

ARTICLES

Calas, Terrington. "Bultman's Singularity." *New Orleans Art Review* (September/October 1993): 2-5.

Firestone, Evan. "Fritz Bultman's Collages." *Arts Magazine* 56 (December 1981): 63-65.

_____. "Fritz Bultman: The Case of the Missing 'Irascible.'" *Archives of American Art Journal* 34 (1994): 11-20.

Friedman, B. H. "'The Irascibles': A Split Second in Art History." *Arts Magazine* 53 (September 1978): 96-102.

_____. "In Memoriam: An 'Irascible.'" *Arts Magazine* 60 (January 1986): 78-79.

Hopkins, Budd. "The Collages of Fritz Bultman." *Provincetown Arts* 2 (1986): 11, 16.

Kingsley, April. "Opening and Closing: Fritz Bultman's Sculpture." *Arts Magazine* 50 (January 1976): 82-83.

_____. "Constructing in Color: Fritz Bultman's Collages and Walls." *Art Quarterly* 15 (New Orleans Museum of Art: July-September 1993): 8-9.

Shuebrook, Ron. "Fritz Bultman Remembered." *Provincetown Arts* 10 (1994): 84-86.

Stephens, Michael. "Fritz Bultman and Myron Stout." *Provincetown Arts* 12 (1996): 48-51.

Suro, Dario. "La Pintura en Neuvo York." *Acento Cultural* 6 (January/February 1960): 46-48.

REVIEWS

Ashton, Dore. "Art: Respect for Subject." *New York Times,* 31 January 1959, 10.

_____. "Art: A Painter Turns to Sculpture." *New York Times,* 29 January 1960, 16.

Bell, Jane. "Fritz Bultman." *Arts Magazine* 48 (February 1974): 62.

Burrows, Carlyle. "Art of the Week: A Varied Group Show at Art Academy." *New York Herald Tribune,* 25 May 1947, 7(V).

Campbell, Lawrence. "Fritz Bultman." *Artnews* 62 (December 1963): 11.

Collier, Alberta. "Delgado Shows Modern Art by Early Masters." *New Orleans Times-Picayune,* 3 November 1959, 5.

Cotter, Holland. "Fritz Bultman: Abstract Drawings 1958-1961." *New York Times,* 19 November 1993, 30(C).

Crimp, Douglas. "Fritz Bultman." *Artnews* 73 (March 1974): 99-100.

Franca, J. -A. "Bultman." *Aujourd'hui, Art et Architecture* no. 27 (June 1960): 48.

Hess, Thomas B. "Fritz Bultman." *Artnews* 48 (February 1950): 50.

Kingsley, April. "New York Letter." *Art International,* 20 March 1974, 58.

_____. "Motherwell, Bultman and Ross Uptown." *Soho Weekly News,* 29 January 1976, 19.

Kramer, Hilton. "Art: Fritz Bultman Restates His Metaphors." *New York Times,* 24 January 1976, 22.

Krasne, Belle. "Fritz Bultman Bows." *Art Digest,* 1 February 1950, 19.

Kuspit, Donald. "Fritz Bultman: Bertha and Karl Leubsdorf Art Gallery, Hunter College." *Artforum* 26 (November 1987): 130.

Preston, Stuart. "Abstract Painting Heads Week's Art." *New York Times,* 4 February 1950, 13.

_____. "In an Abstract Vein." *New York Times,* 16 September 1951, 11(2).

_____. "By Léger and Others." *New York Times,* 21 September 1952, 9(2).

Raynor, Vivien. "In the Galleries: Fritz Bultman." *Arts Magazine* 38 (February 1964): 22.

_____. "Dubufett and Bultman in Storrs." *New York Times,* 10 December 1989, 44(23).

Sandler, Irving. "Fritz Bultman." *Artnews* 57 (February 1959): 13.

Waddington, Chris. "Fritz Bultman: A Modern Master at NOMA." *New Orleans Times-Picayune,* 27 August 1993, 13 (Entertainment Guide).

ARTIST'S WRITINGS

Bultman, Fritz. "Cahier Leaf." *It is* 3 (Winter/Spring 1959): 53.

_____. "The Achievement of Hans Hofmann." *Artnews* 62 (September 1963): 43-45, 54-55.

_____. "About My Drawings." *Texas Quarterly* 16 (Austin: University of Texas, Spring 1973): 71-77.

_____. "Fritz Bultman - Portfolio: A Statement on Collage." *Cornell Review* 6 (Ithaca: Cornell University, Summer 1979): 43-45.

_____. "Possibilities for a Renewed Tradition of Catholic Art in the United States." *New Catholic World* 223 (January/February 1980): 29-31.

CHECKLIST OF THE EXHIBITION

Lovers, 1962
Pasted paper, gouache, and crayon
29 x 23 inches
Collection of Vera and Stephen L. Schlesinger,
New York

Summer, 1962
Pasted paper, gouache, and crayon
23 x 29 inches
Lent by the estate of the artist and courtesy of
Gallery Schlesinger, Ltd., New York

Take-off, 1963
Pasted paper, gouache, and crayon
29 x 23 inches
Lent by the estate of the artist and courtesy of
Gallery Schlesinger, Ltd., New York

Red, White and Brown, 1964
Pasted paper, gouache, and crayon
25 1/2 x 19 1/2 inches
Lent by the estate of the artist and courtesy of
Gallery Schlesinger, Ltd., New York

Black and Ochre, 1965
Pasted paper and gouache
19 1/2 x 25 3/4 inches
Collection of Abby and B. H. Friedman, New York

Ilium, 1966
Pasted paper, gouache, and pencil
23 x 29 inches
Collection of Mr. and Mrs. George P. Kramer,
New York

Red Rope, 1967
Pasted paper, gouache, and crayon
36 x 32 inches
Lent by the estate of the artist and courtesy of
Gallery Schlesinger, Ltd., New York

Wave Over Lap II, 1967
Pasted paper, gouache, and crayon
48 x 32 inches
Lent by the estate of the artist and courtesy of
Gallery Schlesinger, Ltd., New York

Explorer: Sky and Water, 1968
Pasted paper, gouache, and crayon
34 3/8 x 28 3/4 inches

Bowdoin College Museum of Art, Brunswick, Maine;
gift of William H. Alexander

Boot, 1969
Pasted paper, gouache, and pencil
35 x 30 inches
Lent by the estate of the artist and courtesy of
Gallery Schlesinger, Ltd., New York

Red Lap Barrier, 1971
Pasted paper and gouache
46 x 37 1/2 inches
Collection of Donald Windham, New York

In the Wave, 1973
Pasted paper and gouache
64 x 48 inches
Collection of Lola and Allen Goldring, Woodbury,
New York

Making the Element, 1973
Pasted paper and gouache
51 x 77 inches
Tulane University Art Collection, New Orleans

Rooting, 1975
Pasted paper and gouache
66 x 48 inches
Lent by the estate of the artist and courtesy of
Gallery Schlesinger, Ltd., New York

The Way Up and the Way Down, 1975
Pasted paper and gouache
90 x 48 inches
National Museum of American Art, Smithsonian
Institution, Washington, D.C.; gift of Mr. and Mrs.
David K. Anderson, Martha Jackson Memorial
Collection

Blue Line Transforming II, 1976
Pasted paper and gouache
36 x 41 inches
Lent by the estate of the artist and courtesy of
Gallery Schlesinger, Ltd., New York

Sky Harp, 1977
Pasted paper and gouache
96 x 48 inches
Lent by the estate of the artist and courtesy of
Gallery Schlesinger, Ltd., New York

Between Two Orbes, 1977
Pasted paper and gouache
14 x 17 inches
Collection of Donald Windham, New York

Geometry of a Wave, 1977
Pasted paper and gouache
14 x 17 inches
Lent by the estate of the artist and courtesy of
Gallery Schlesinger, Ltd., New York

Mardi Gras, 1978
Pasted paper and gouache
96 1/2 x 48 1/2 inches
Hunter College, City University of New York

November Wave, 1978
Pasted paper and gouache
53 x 53 inches
Montclair Art Museum, Montclair, New Jersey;
museum purchase with funds provided by Mr. and
Mrs. Barksdale Penick Jr. and the Acquisition Fund
79.5

Anthony's Small Collage, 1978
Pasted paper and gouache
12 x 16 inches
Collection of Anthony Bultman, New Orleans

Upwelling, 1979
Pasted paper, gouache, and push pins
48 x 89 inches
Lent by the estate of the artist and courtesy of
Gallery Schlesinger, Ltd., New York

Blue Wave I, 1979
Pasted paper and gouache
48 x 80 inches
Collection of Mr. and Mrs. William Frankel,
Philadelphia

Floating II, 1980
Pasted paper and gouache
76 x 44 inches
Collection of Johann Bultman, New Orleans

Reap, 1981
Pasted paper and gouache
48 x 76 inches
Lent by the estate of the artist and courtesy of
Gallery Schlesinger, Ltd., New York

Other, 1981
Pasted paper and gouache
52 x 46 inches
Lent by the estate of the artist and courtesy of
Gallery Schlesinger, Ltd., New York

Wind on the Water, 1982
Pasted paper and gouache
56 x 48 inches
Timothy Foley, Tilden-Foley Gallery, New Orleans

Notte, 1983
Pasted paper and gouache
48 x 37 1/2 inches
Collection of John and Kate Turbyfill, Virginia Beach,
Virginia

Ante Luce, 1983
Pasted paper and gouache
47 x 69 inches
Collection of Roger Houston Ogden, New Orleans

Bonfire, 1983
Pasted paper and gouache
40 x 53 inches
Lent by the estate of the artist and courtesy of
Gallery Schlesinger, Ltd., New York

Interrupted, 1984
Pasted paper and gouache
23 x 29 inches
Lent by the estate of the artist and courtesy of
Gallery Schlesinger, Ltd., New York

Daphne I, 1984
Pasted paper and gouache
29 x 25 inches
Lent by the estate of the artist and courtesy of
Gallery Schlesinger, Ltd., New York

The Wave, 1984
Pasted paper and gouache
23 x 29 inches
Lent by the estate of the artist and courtesy of
Gallery Schlesinger, Ltd., New York

January Circle, 1985
Pasted paper, gouache, and pencil
30 x 40 inches
Lent by the estate of the artist and courtesy of
Gallery Schlesinger, Ltd., New York

FRITZ BULTMAN: COLLAGES

COLOR PLATES

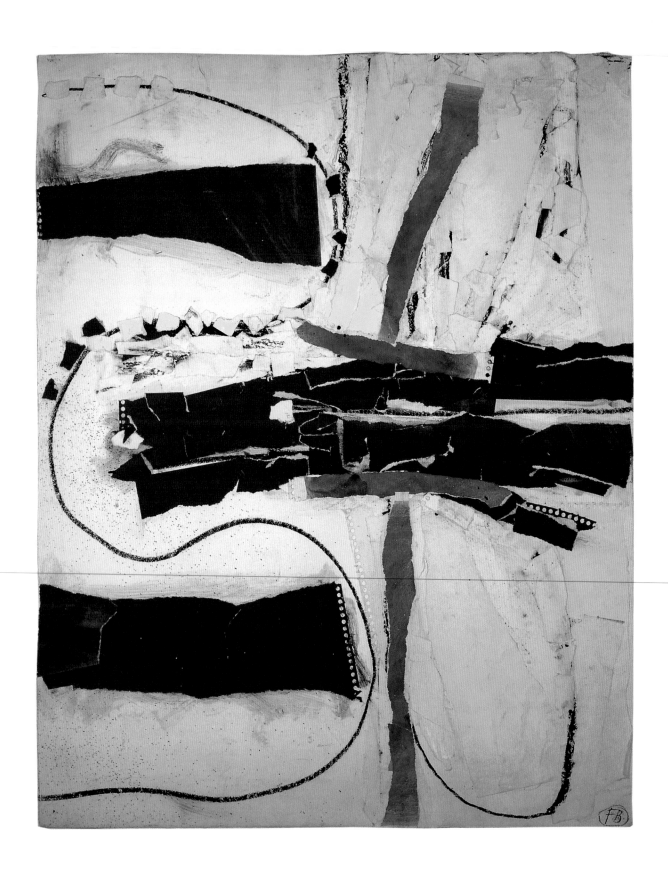

PLATE 1 *Lovers*, 1962
 Pasted paper, gouache, and crayon
 29 x 23 inches
 Collection of Vera and Stephen L. Schlesinger, New York

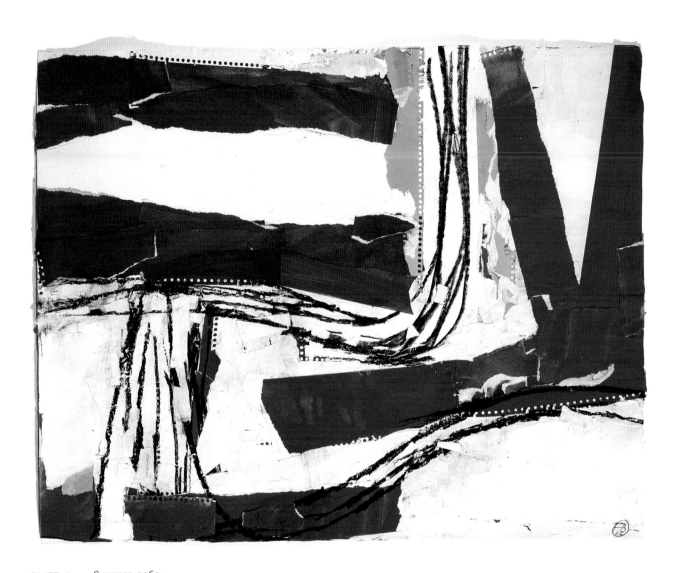

PLATE 2 *Summer*, 1962
Pasted paper, gouache, and crayon
23 x 29 inches
Lent by the estate of the artist and courtesy of Gallery Schlesinger, Ltd., New York

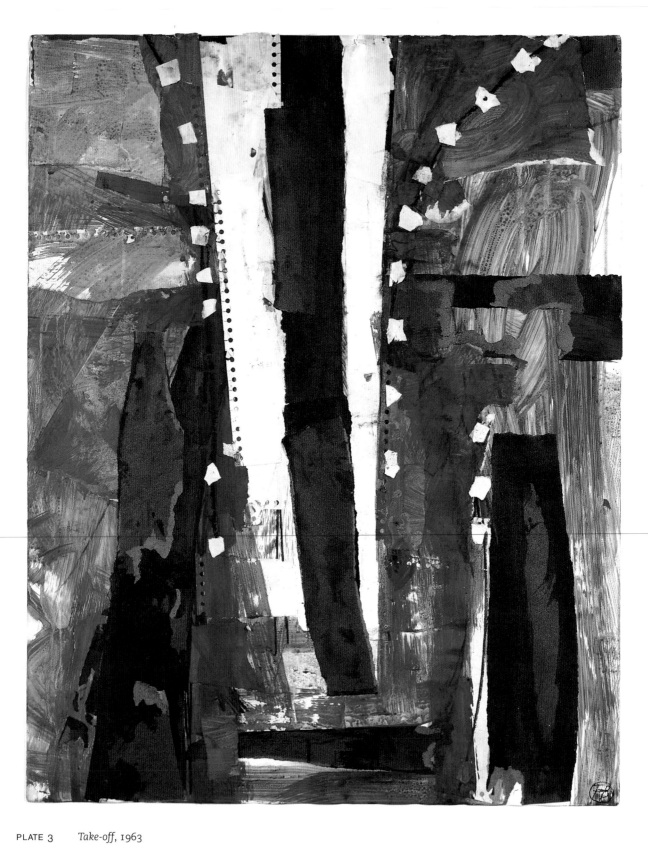

PLATE 3 *Take-off*, 1963
Pasted paper, gouache, and crayon
29 x 23 inches
Lent by the estate of the artist and courtesy of Gallery Schlesinger, Ltd., New York

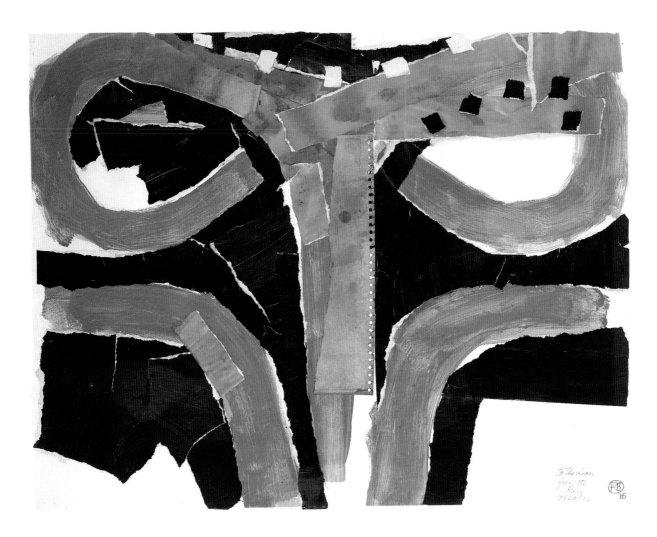

PLATE 4 *Black and Ochre*, 1965
 Pasted paper and gouache
 19 1/2 x 25 3/4 inches
 Collection of Abby and B. H. Friedman, New York

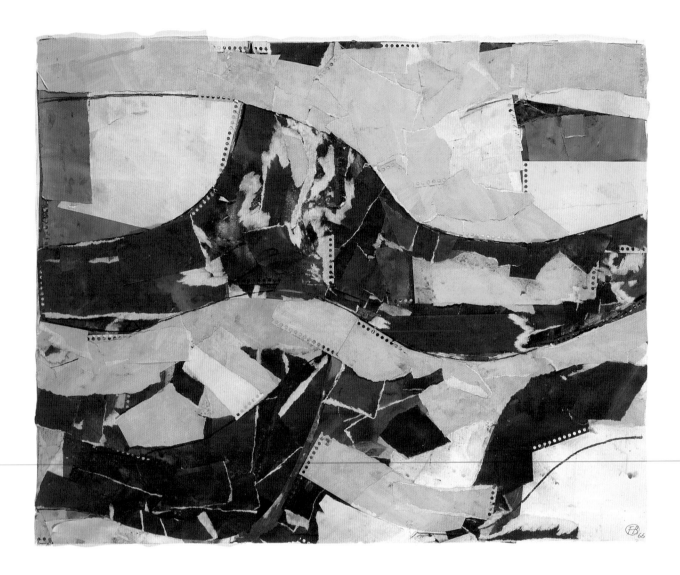

PLATE 5 *Ilium*, 1966

Pasted paper, gouache, and pencil

23 x 29 inches

Collection of Mr. and Mrs. George P. Kramer, New York

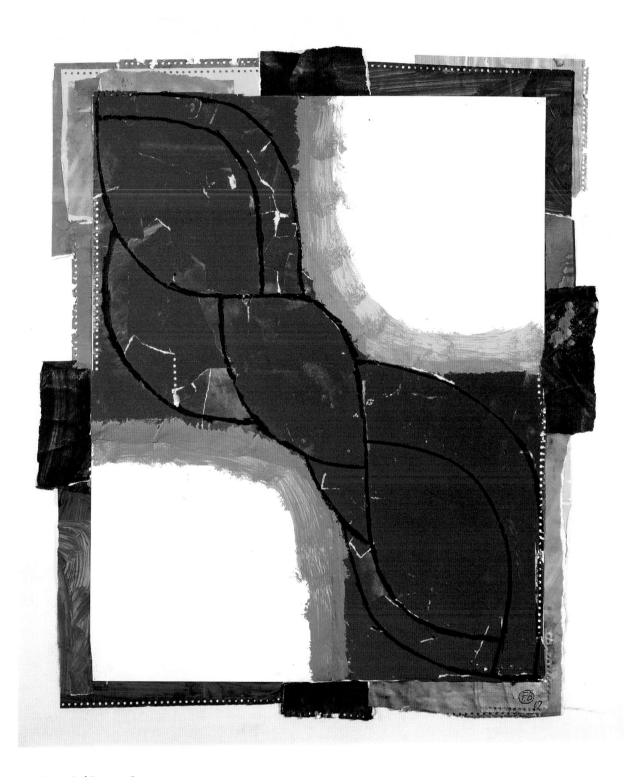

PLATE 6 *Red Rope*, 1967
Pasted paper, gouache, and crayon
36 x 32 inches
Lent by the estate of the artist and courtesy of Gallery Schlesinger, Ltd., New York

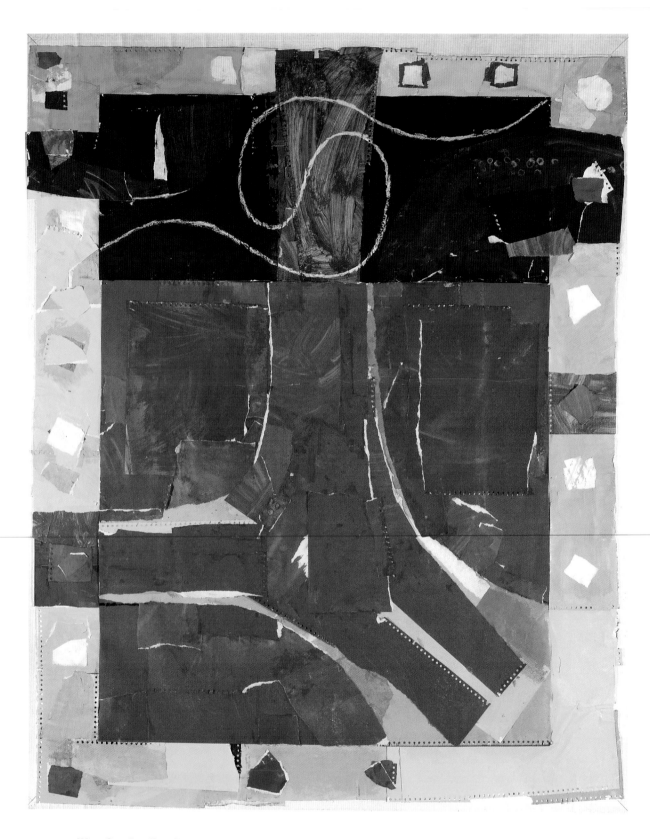

PLATE 7 *Wave Over Lap II*, 1967
Pasted paper, gouache, and crayon
48 x 32 inches
Lent by the estate of the artist and courtesy of Gallery Schlesinger, Ltd., New York

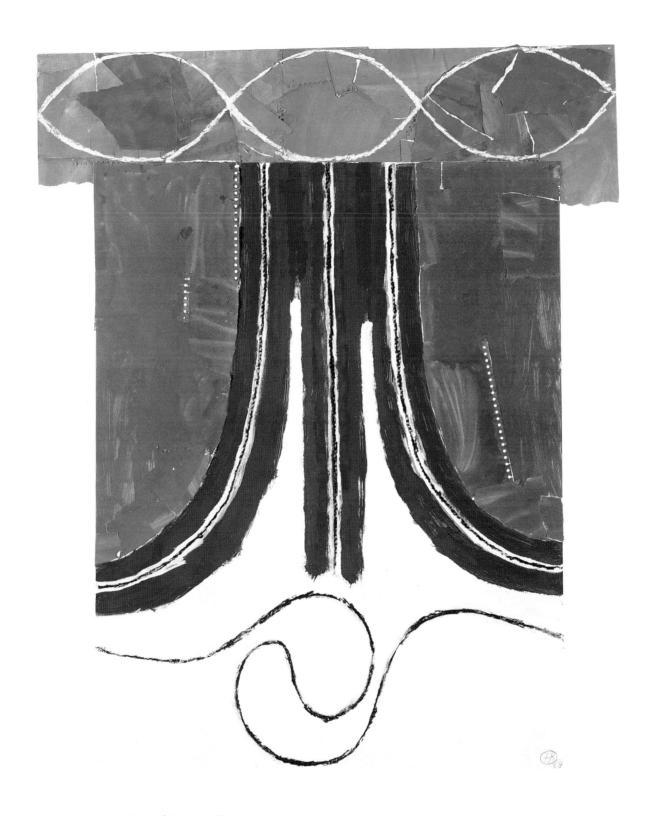

PLATE 8 *Explorer: Sky and Water*, 1968
Pasted paper, gouache, and crayon
34 3/8 x 28 3/4 inches
Bowdoin College Museum of Art, Brunswick, Maine; gift of William H. Alexander

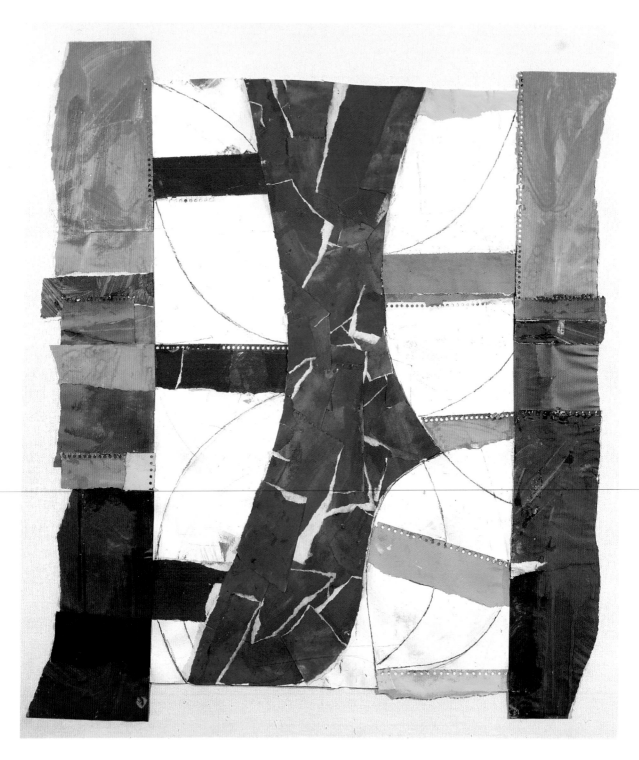

PLATE 9 *Boot*, 1969
 Pasted paper, gouache, and pencil
 35 x 30 inches
 Lent by the estate of the artist and courtesy of Gallery Schlesinger, Ltd., New York

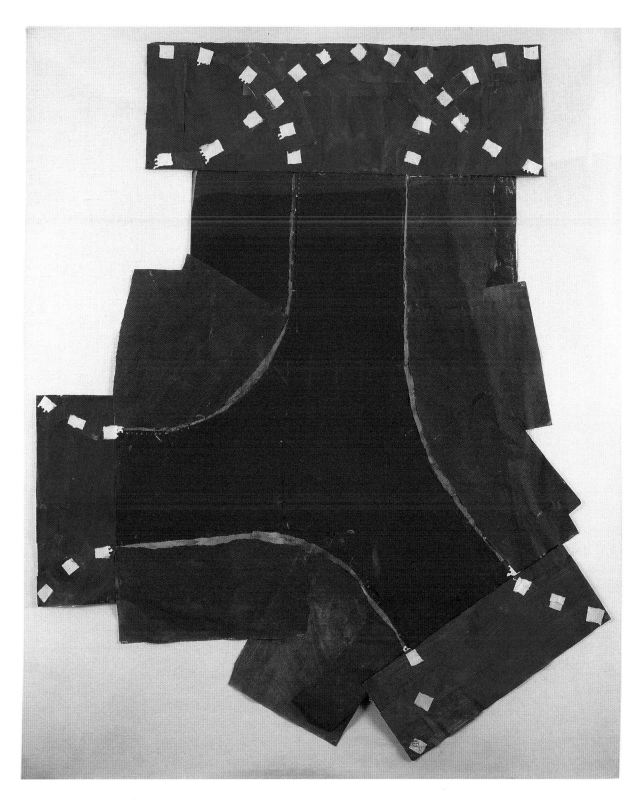

PLATE 10 *Red Lap Barrier*, 1971
Pasted paper and gouache
46 x 37 1/2 inches
Collection of Donald Windham, New York

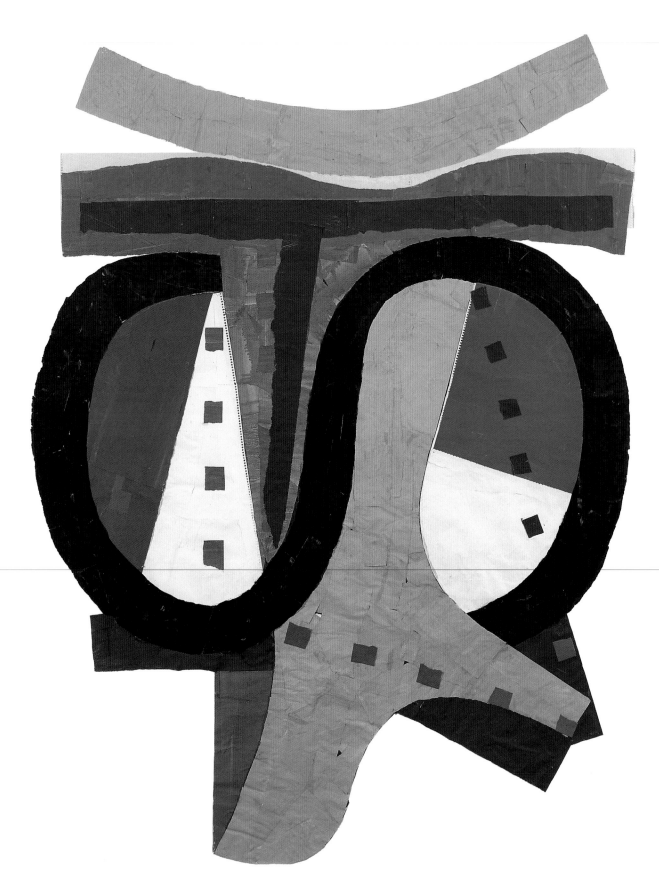

PLATE 11 *In the Wave*, 1973
 Pasted paper and gouache
 64 x 48 inches
 Collection of Lola and Allen Goldring, Woodbury, New York

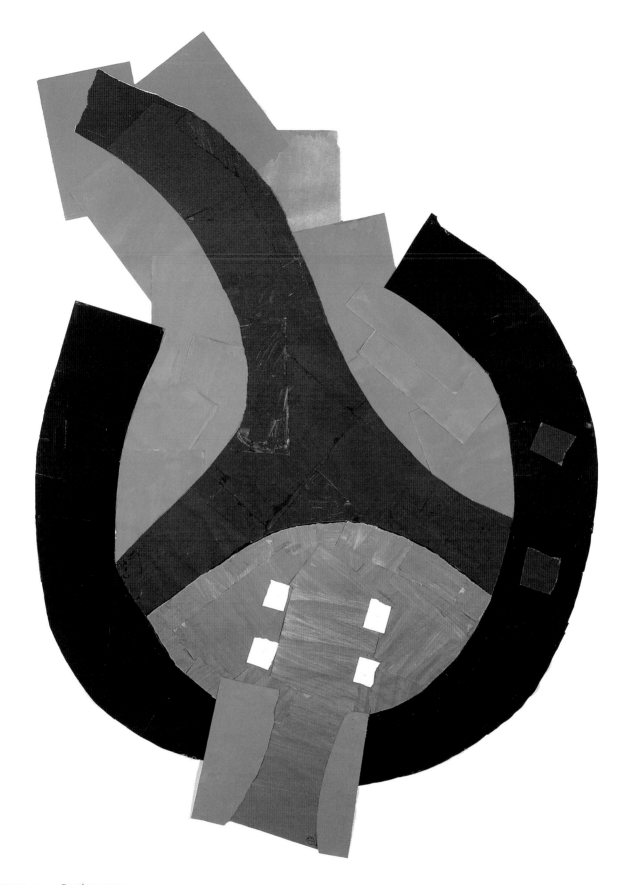

PLATE 12 *Rooting*, 1975
Pasted paper and gouache
66 x 48 inches
Lent by the estate of the artist and courtesy of Gallery Schlesinger, Ltd., New York

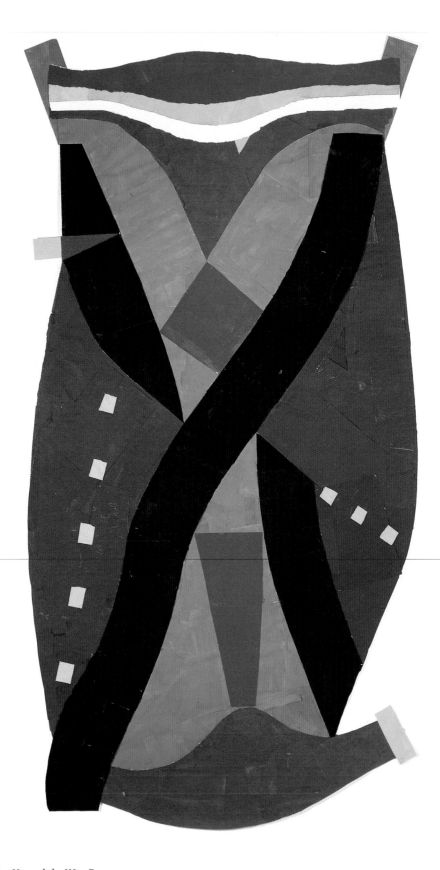

PLATE 13 *The Way Up and the Way Down*, 1975
Pasted paper and gouache
90 x 48 inches
National Museum of American Art, Smithsonian Institution, Washington, D.C.;
gift of Mr. and Mrs. David K. Anderson, Martha Jackson Memorial Collection

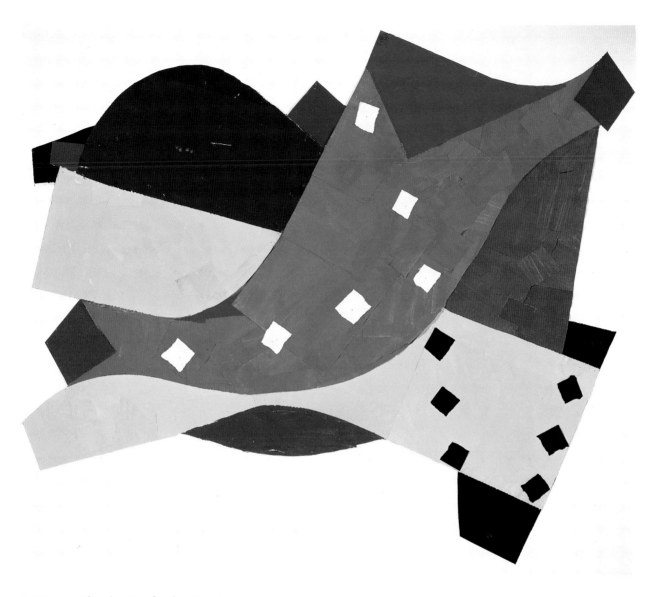

PLATE 14 *Blue Line Transforming II*, 1976
 Pasted paper and gouache
 36 x 41 inches
 Lent by the estate of the artist and courtesy of Gallery Schlesinger, Ltd., New York

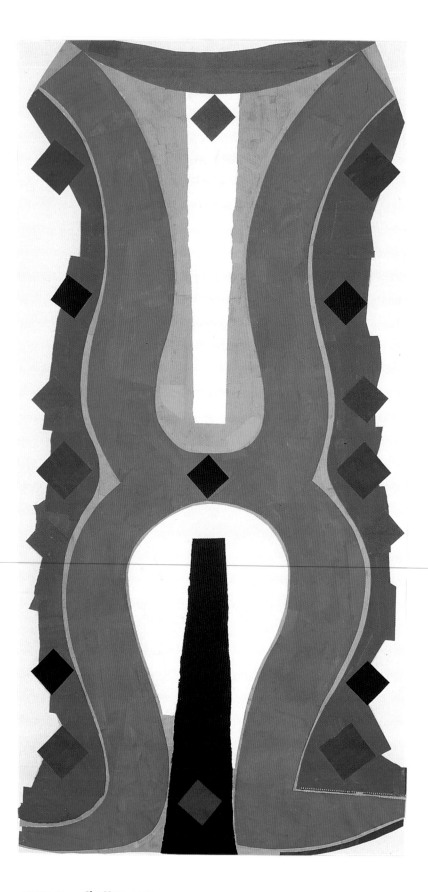

PLATE 15 *Sky Harp*, 1977
Pasted paper and gouache
96 x 48 inches
Lent by the estate of the artist and courtesy of Gallery Schlesinger, Ltd., New York

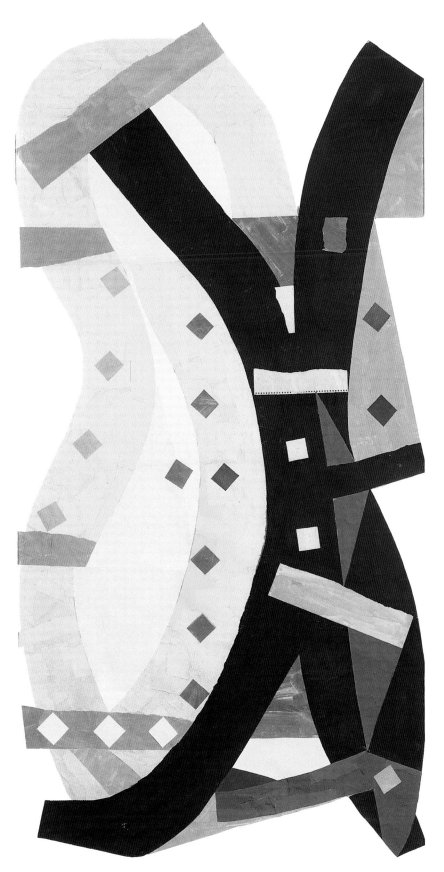

PLATE 16 *Mardi Gras*, 1978
 Pasted paper and gouache
 96 1/2 x 48 1/2 inches
 Hunter College, City University of New York

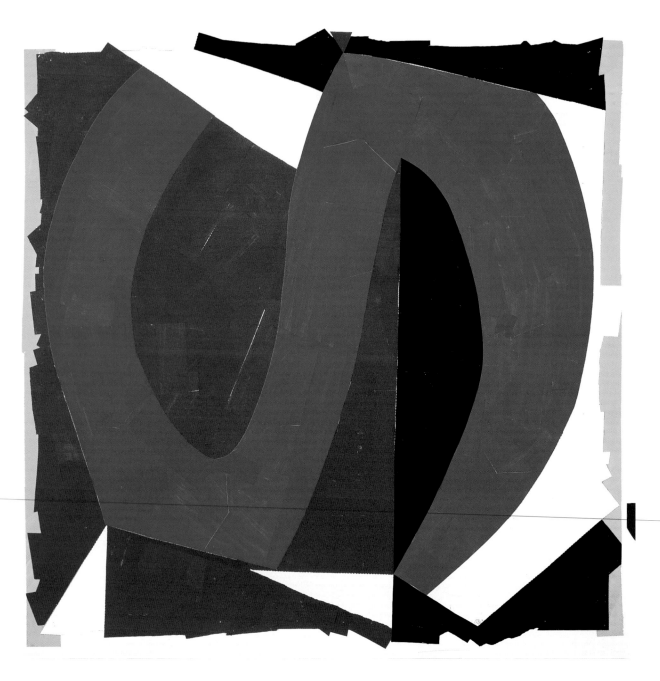

PLATE 17 *November Wave*, 1978
 Pasted paper and gouache
 53 x 53 inches
 Montclair Art Museum, Montclair, New Jersey; museum purchase with funds
 provided by Mr. and Mrs. Barksdale Penick Jr. and the Acquisition Fund. 79.5

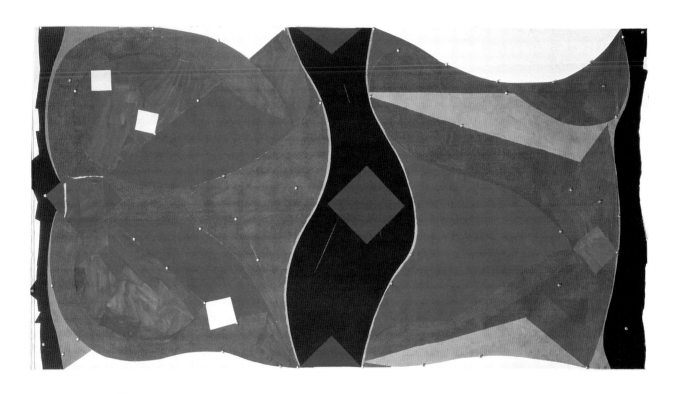

PLATE 18 *Upwelling*, 1979
 Pasted paper, gouache, and push pins
 48 x 89 inches
 Lent by the estate of the artist and courtesy of Gallery Schlesinger, Ltd., New York

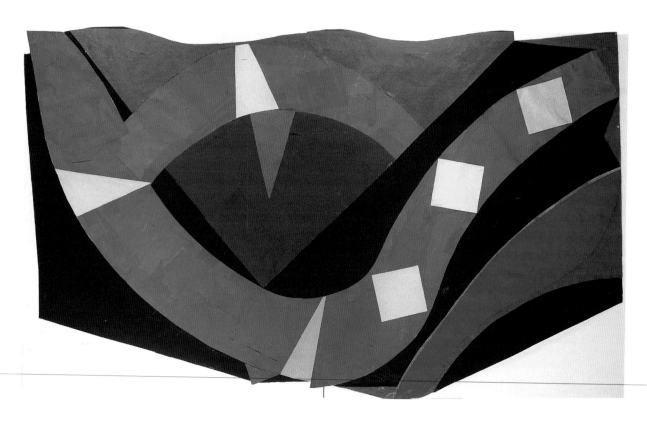

PLATE 19 *Blue Wave I*, 1979
Pasted paper and gouache
48 x 80 inches
Collection of Mr. and Mrs. William Frankel, Philadelphia

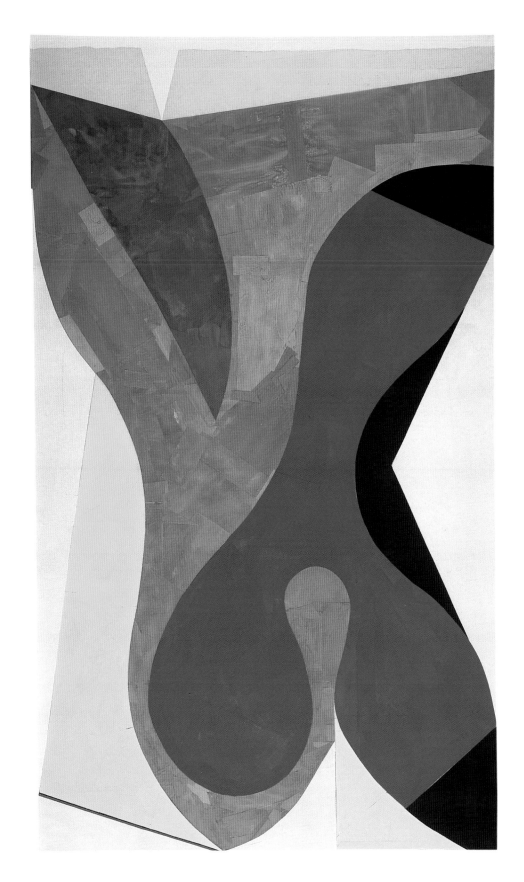

PLATE 20 *Floating II*, 1980
 Pasted paper and gouache
 76 x 44 inches
 Collection of Johann Bultman, New Orleans

71 FRITZ BULTMAN: COLLAGES

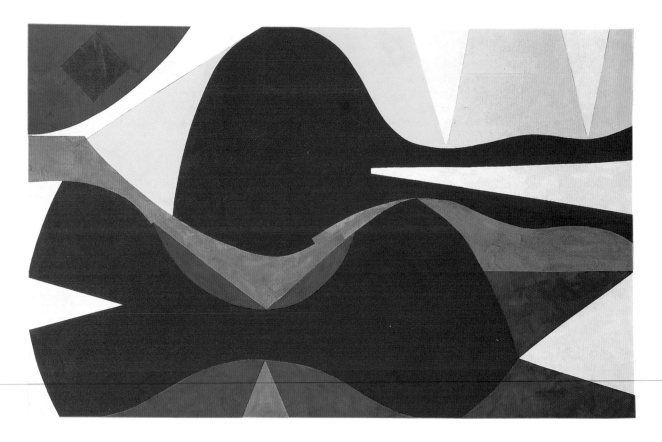

PLATE 21 *Reap*, 1981
Pasted paper and gouache
48 x 76 inches
Lent by the estate of the artist and courtesy of Gallery Schlesinger, Ltd., New York

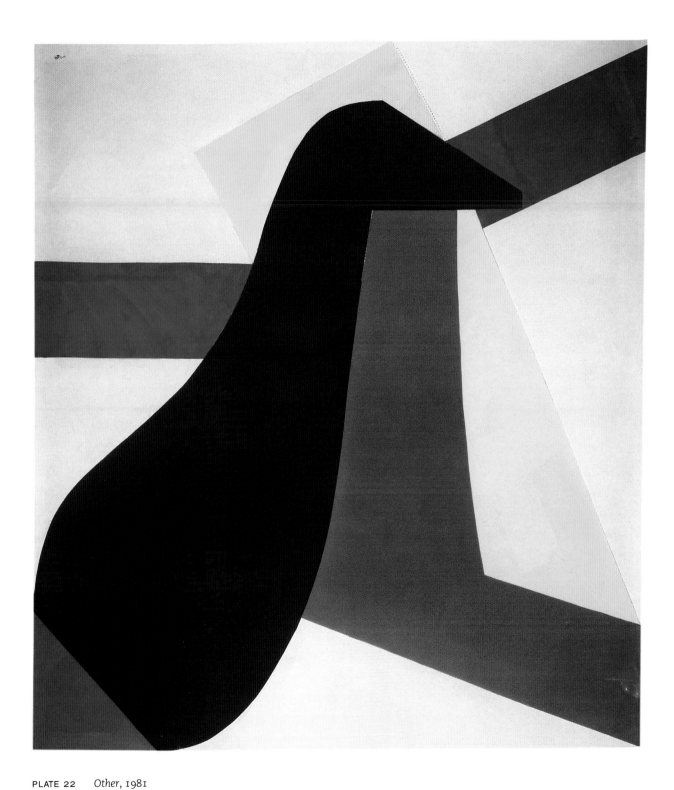

PLATE 22 *Other*, 1981
Pasted paper and gouache
52 x 46 inches
Lent by the estate of the artist and courtesy of Gallery Schlesinger, Ltd., New York

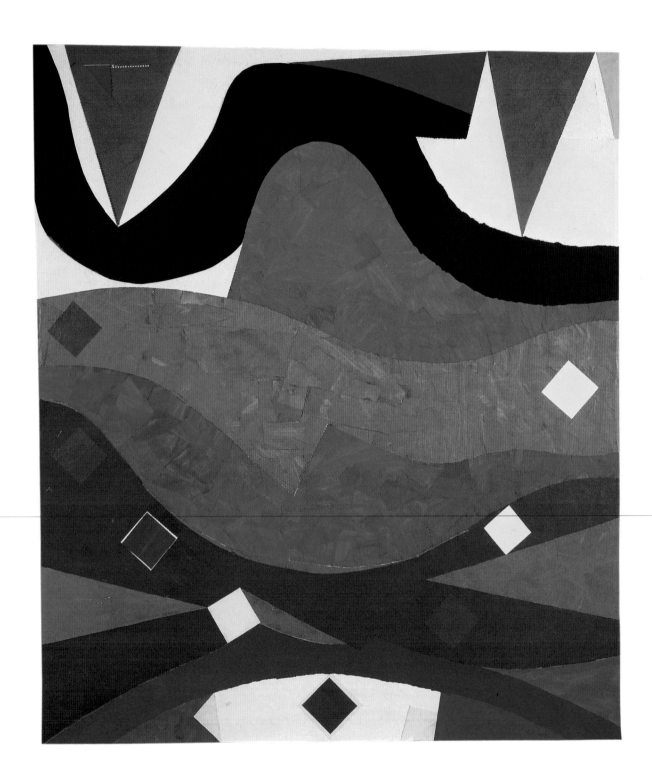

PLATE 23 *Wind on the Water*, 1982
 Pasted paper and gouache
 56 x 48 inches
 Timothy Foley, Tilden-Foley Gallery, New Orleans

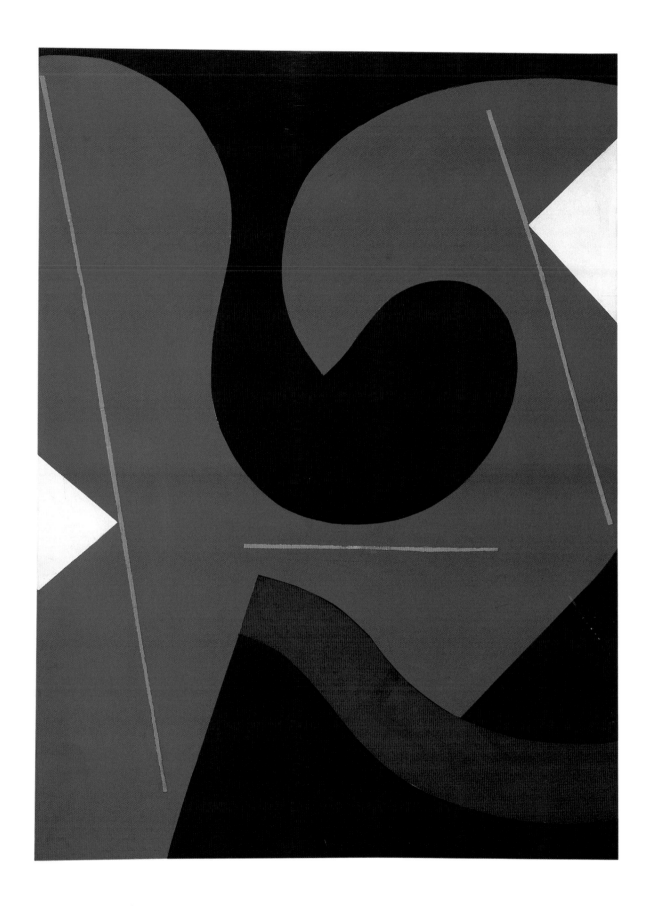

PLATE 24 *Notte*, 1983
 Pasted paper and gouache
 48 x 37 1/2 inches
 Collection of John and Kate Turbyfill, Virginia Beach, Virginia

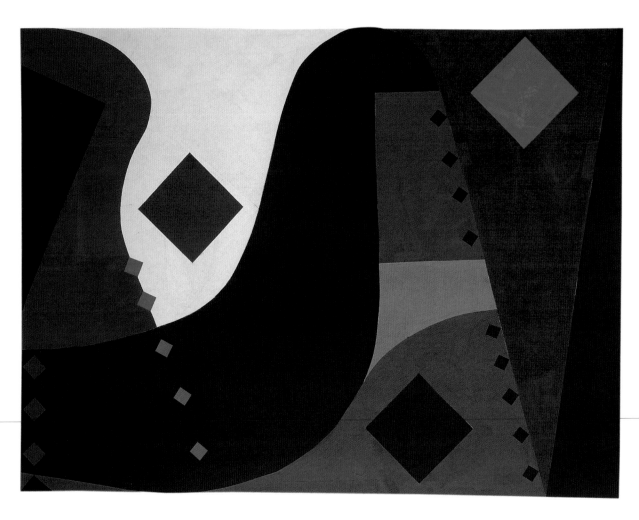

PLATE 25 *Ante Luce*, 1983
 Pasted paper and gouache
 47 x 69 inches
 Collection of Roger Houston Ogden, New Orleans

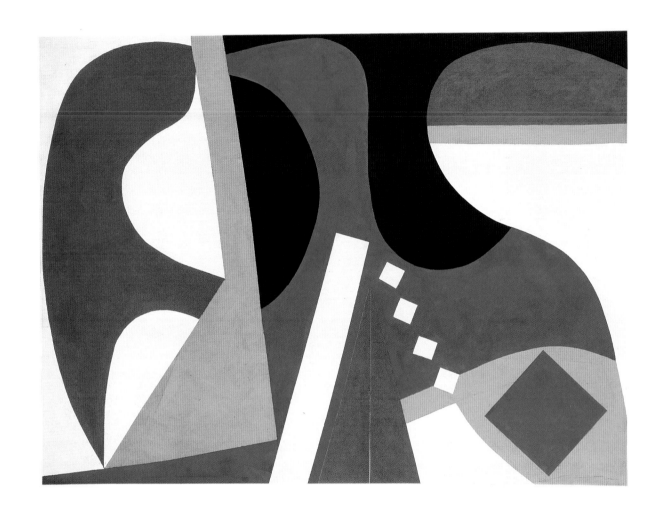

PLATE 26 *Bonfire*, 1983
 Pasted paper and gouache
 40 x 53 inches
 Lent by the estate of the artist and courtesy of Gallery Schlesinger, Ltd., New York

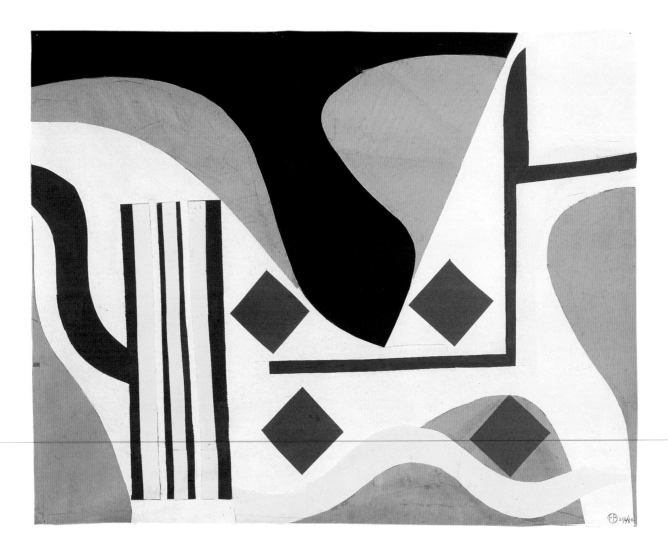

PLATE 27 *Interrupted*, 1984
Pasted paper and gouache
23 x 29 inches
Lent by the estate of the artist and courtesy of Gallery Schlesinger, Ltd., New York

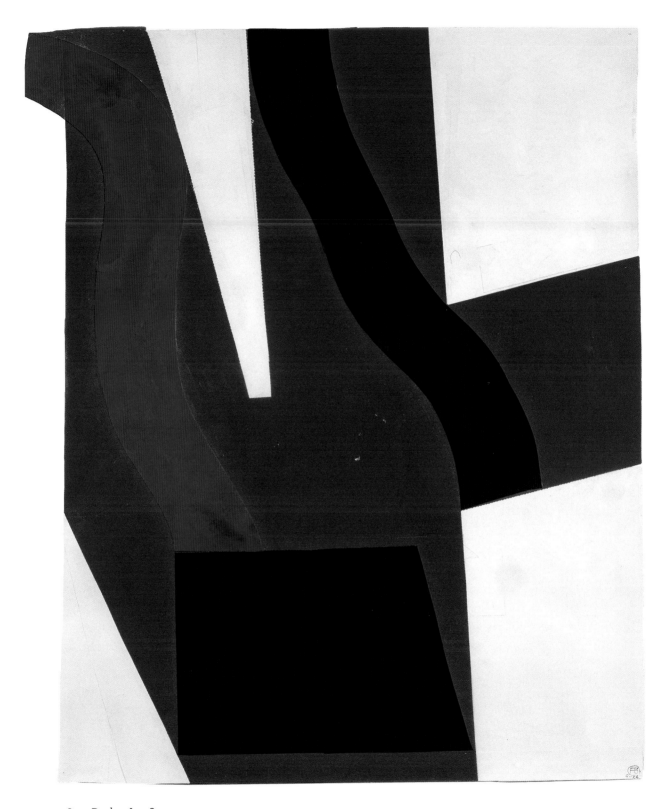

PLATE 28 *Daphne I*, 1984
Pasted paper and gouache
29 x 25 inches
Lent by the estate of the artist and courtesy of Gallery Schlesinger, Ltd., New York

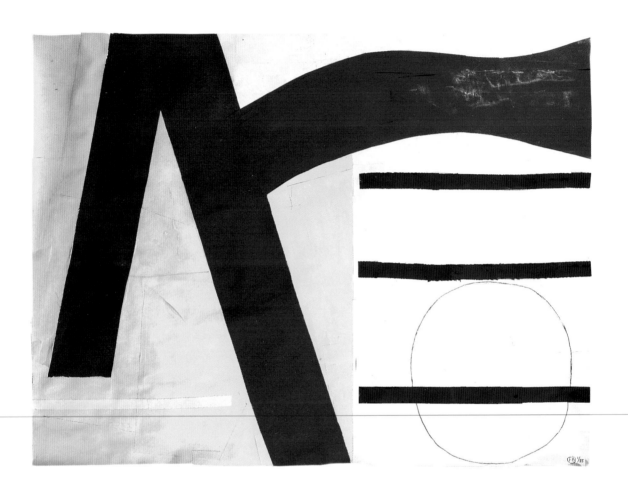

PLATE 29 *January Circle*, 1985
Pasted paper, gouache, and pencil
30 x 40 inches
Lent by the estate of the artist and courtesy of Gallery Schlesinger, Ltd., New York